A
User's
Guide
Simon Ford

# the
# situationist
# international

Books are to

# the situationist international

Black Dog Publishing

Architecture Art Design Fashion History
Photography Theory and Things

© 2005 Black Dog Publishing Limited

The author has asserted his moral right to the work comprising The Situationist International A User's Guide.

Written by Simon Ford
Designed by Marit (www.graphic-shapes.co.uk)
Printed in Italy by Printer Trento S.r.l.

Black Dog Publishing Limited
Unit 4.04 Tea Building
56 Shoreditch High Street
London E1 6JJ

T +44 (0)207613 1922
F +44 (0)207613 1944
E info@bdp.demon.co.uk
www.bdpworld.com

All opinions expressed within this publication are those of the author and not necessarily the publisher.

British Library Cataloguing-in-Publication Date.
A catalogue record for this book is available from the British Library.

ISBN 1 904772 05 6

Every effort has been made to trace the copyright holders, but if any have been inadvertently overlooked the publishers will be pleased to make the necessary arrangements at the first opportunity.

## Acknowledgements

Many people have helped me with the writing of this book. In particular I would like to thank Dinah Winch, Anthony Davies, Jakob Jakobsen, Tahani Nadim, Duncan McCorquodale, Kathy Battista, Marit Münzberg and Josephine Pryde. Finally I must acknowledge a very real debt to the many people that have researched and written about the SI, especially Gérard Berréby, Christophe Bourseiller, Len Bracken, Stewart Home, and Andrew Hussey. This book is dedicated to my brothers, Richard and Trevor.

# Introduction

Formed in 1957 and disbanded in 1972, the Situationist International (SI) remains the benchmark against which all would-be avant-gardists must measure themselves. This book provides the first accessible and concise guide to the group, encompassing all the main events of its history, outlining its many critical theories concerning the 'society of the spectacle', and providing access to the latest research on the group. With the SI now well established as part of the canon of the post war avant-garde, its works and commentaries on its works, are regularly recommended to students in such diverse disciplines as fine art, architecture, and cultural studies. In 1988 a leading member of the SI, Guy Debord, stated that such a profusion of information created a contradiction "between the mass of information collected…and the time and intelligence available to analyse it".[1] This plethora of literature about the group, as Debord implied, makes it confusing for the beginner to know where to start. This book has been written to provide just such a starting point.

Debord, Guy, *Comments on the Society of the Spectacle*, London: Verso, 1990, thesis 30.

The story of the SI necessarily begins with its immediate precursors, the Lettriste International (LI). Founded by Debord and a gang of Parisian Left Bank delinquents in 1952, the group soon distanced itself from the older Lettriste movement led by Isidore Isou. Over the next few years the LI developed many of the practices that would become synonymous with the SI, namely *détournement*, psychogeography, and unitary urbanism. The LI disbanded in 1957 to make way for the formation of the SI. At first hesitatingly and then with growing confidence Debord took control of the new group. He edited its journal, *Internationale situationniste*, and ruthlessly pursued the expulsion of anybody not reaching his high standards for the group. The first of the great upheavals that periodically shook the SI took place in 1962 with the expulsion of the most artistically inclined members, the so-called 'Spurists' and 'Nashists'.

The group's restrictive and exclusive recruitment policy meant that it was never in danger of becoming a mass movement, but with its small group of dedicated followers it remained well positioned for agitation and conspiracy. At any one time its membership averaged between ten and 20 people, predominantly male and mostly based in Paris.[2] This post-'split' era saw the publication, in 1967, of the two key works of Situationist theory, Debord's

"In all, 63 men and seven women from 16 different countries were members at one time or another." See: Ken Knabb ed, *Situationist International Anthology*, Berkeley: Bureau of Public Secrets, 1981, p. 376.

9

*The Society of the Spectacle* and Raoul Vaneigem's *The Revolution of Everyday Life*. Shortly after these books appeared the group played its small but none the less significant part in the events of May '68. The end of that uprising can now be seen as the harbinger of the death of the SI's own political and cultural interventions. The final chapter in this book examines the reasons for the group's dissolution in 1972 and outlines its subsequent legacy, especially its infiltration into popular culture.

At particular points in the following narrative I break the chronological structure to provide brief accounts of key artists associated with the SI, namely Ralph Rumney, Asger Jorn, Giuseppe Pinot-Gallizio, and Constant. Each of these artists could justifiably claim significance for their work and careers beyond their membership of the SI. This independent importance equally applies to the groups immediately preceding the foundation of the SI; the Lettriste movement, Cobra, and The International Movement for an Imaginist Bauhaus. But this book is about the SI and that means there is relatively limited space available for these artists and art movements outside of their involvement with the SI. Ironically it is around these 'peripheral' areas that

Just one example of this being the long overdue reassessment of the Second Situationist International currently being carried out and recorded by Infopool. See http://www.infopool.org.uk/ situpool.htm

the most fruitful research concerning the SI is taking place.[3] This book would not be possible without the help of the many people involved in the dissemination of Situationist ideas through the translation and publication of key texts both in print form and on the Internet. The Further Information section at the end of this book provides a listing of the best examples of this work plus the addresses for some of the most useful websites currently available.

Despite the many individuals involved with the SI, this book shares with many others an arguably disproportionate focus on the life and work of one man, Guy Debord. This is problematic for a number of reasons. Throughout his life Debord worked best in collaboration with other artists and writers, and over the years these included Michèle Bernstein, Gil J Wolman, Asger Jorn, and Alice Becker-Ho. Without the supporting structure of the SI and the contacts it gave him, Debord could have remained just an obscure character on the fringes of French culture. Equally, however, without the dogmatic and dogged commitment of Debord the readily conflictive nature of the SI would have meant its early demise. For many years the survival of the SI was Debord's main vocation and, as such, it must be considered as one of his greatest achievements.

The importance of Debord in relation to the other members of the SI is just one of many problems for a book about the group. Its opposition to anything resembling academic discourse and its gleeful ridicule of journalistic attempts to describe its operations point to a purposely elusive character. The SI sought to escape these particular forms of understanding and insisted instead on defining itself in its own terms. This was a familiar avant-gardist strategy and not the only one employed by the SI. Others included the use of exaggeration and self-mythology. For example, Debord knew that the best way to ensure the SI's immortality from 1972 onwards was to publicly announce its death. It was this instinct for scandal and self-serving embellishment that later attracted the attention of the 'Pop Situationists' Malcolm McLaren and Tony Wilson. However, what these later manifestations of Situationist inspired subversion could never emulate was the group's very longevity and the seriousness of its project. As Debord wrote in 1961, a guide can only take you so far: Revolution is not "showing" life to people, but making them live. A revolutionary organisation must always remember that its objective is not getting its adherents to listen to convincing talks by expert leaders, but getting them to speak for themselves, in order to achieve, or at least strive toward, an equal degree of participation.[4]

Debord, Guy, "For a Revolutionary Judgement of Art", in Knabb, *Situationist International Anthology*, 1981, p. 312.

# The Pre-Situationist Years 1931–1956

chapter one

# Guy Debord and the Lettriste Movement

Guy Debord.

Guy Louis Marie Vincent Ernest Debord was born 28 December 1931 in the Mouzaïa quarter of Paris. His father, Martial Debord, died in 1936 when Debord was just four years old. His mother, Paulette, subsequently remarried and Guy spent much of his childhood under the care of his maternal grandmother Lydie Hélène Fantouiller, known as 'Manou'. The family's slow but steady decline in fortunes was only halted when Paulette met Charles Labaste, a prosperous notary based first in Pau and then in Cannes where Debord finished his schooling.[1] As a child he spent hours playing with his toy soldiers (an interest that would later develop into a love of military strategy and the works of Clausewitz and Machiavelli). With maturity his reading preference gravitated towards literary outsiders and rebels, particularly the poet and adventurer Arthur Rimbaud, author of *Une Saison en enfér* (*A Season in Hell*) and the seeker of poetic insights through the "rational disordering of the senses". An avid visitor to the cinema Debord also styled himself on the 'literary bandit' Pierre-François Lacenaire, a historical character that featured in Marcel Carné's classic 1945 film *Les Enfants du Paradis* (*The Children of Paradise*).

Debord's childhood and adolescence coincided with a period of great change in French society. Fundamental transformations in lifestyle occurred with the expansion of university education, more leisure time for workers, and increasing amounts of disposable income being spent on consumer goods such as fridges, washing machines and televisions. On the cultural front, the Surrealists still maintained a firm hold over the avant-garde, with their charismatic leader André Breton and their exploration of the use of the unconscious and chance in the making of art and in the conversion of ordinary life into the extraordinary. Debord quickly saw through Breton's increasing supernaturalism and tended to favour figures peripheral to the group, such as Breton's friend and eventual suicide, Jacques Vaché, and the boxer-adventurer-provocateur Arthur Cravan.[2] But Debord followed the Surrealists in his taste for the work of the nineteenth century author of the nightmarish novel *Les Chants de Maldoror* (*Maldoror and Poems*), Isidore Lucien Ducasse (Comte de Lautréamont).[3] In this book Lautréamont famously described beauty "as the chance meeting on a dissecting table of a sewing

[1] For the best account of Debord's childhood see Andrew Hussey, *The Game of War: The Life and Death of Guy Debord*, London: Jonathan Cape, 2001, pp. 13-26.

[2] Cravan was born in Lausanne in 1887 as Fabian Avenarius Lloyd. He first arrived in Paris in 1911 and disappeared forever in Mexico in 1919. In later years Debord used his influence at Éditions Gérard Lebovici, to have a collection of Cravan's work published. See: Arthur Cravan, *Oeuvres: Poems, Articles, Lettres*, Paris: Éditions Gérard Lebovici, 1987. For accounts and examples of work by Cravan and Vaché see Robert Motherwell ed., *The Dada Painters and Poets: An Anthology*, Cambridge, MA: The Belknap Press of Harvard University Press, 1981.

[3] Knight, Paul trans., *Maldoror and Poems*, Harmondsworth: Penguin Books, 1978.

machine and an umbrella". Another of his sayings "Beautiful as the trembling hands of alcoholism" would later find its way into Debord's *Panegyric*.[4]

Debord, Guy, *Panegyric: Volume 1*. London: Verso, 1991, p. 37.

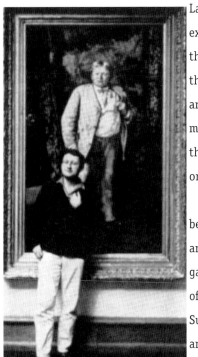

Lautréamont's death, like Debord's, would partly derive from his excessive drinking, in his case, absinthe. Apart from a love of alcohol the main lesson Debord learnt from these various sources was that an interesting life was just as important as the creation of art. Later, borrowing a quote from Chateaubriand, Debord would modestly claim for himself this laudatory self-assessment: "Of the modern French authors of my time, I am therefore the only one whose life is true to his works."[5]

Debord, *Panegyric*, p. 46.

By the 1950s the Surrealists' influence and reputation was beginning to wane. Many individuals in the movement were now rich and famous artists. They were represented by the finest bourgeois art galleries and the national museums of the world fought for possession of examples of their works. New movements, albeit to varying degrees Surrealist in tone, were beginning to emerge, such as Art Informel and Abstract Expressionism. But these held little interest for the young Debord. In 1963 he derided the post war avant-garde for its careerism and for its corruption of earlier avant-gardist ideals. He described the new avant-garde as merely "taking up the style invented before 1920 and exploiting each detail in enormously exaggerated fashion, thereby making this style serve the acceptance and decoration of the present world".[6] Debord would have to look elsewhere for a movement he felt worthy of his involvement. In April 1951, at the age of 19, he attended the Fourth Cannes Film Festival. Bored with the superficiality of film industry glamour, he was excited to come across the Lettristes, a group of artists from Paris determined to upset proceedings and show a film, *Traité de bave et d'éternité* (*Treatise on Slime and Eternity*), by the group's leader, Isidore Isou. Partly in recognition of the group's tenacity, Cannes jurist Jean Cocteau, invented a new prize, the *Prix de l'Avant-Garde*, and awarded it to Isou.

Debord, Guy, "The Situationists and the New Forms of Action in Politics or Art" in Elisabeth Sussman ed., *On the passage of a few people through a rather brief moment in time: the Situationist International 1957-1972*, Boston, MA: MIT Press; Institute of Contemporary Art, Boston, 1989, p. 153.

Isou, whose real name was Jean-Isidore Goldstein, was born in 1925 in Botosani, in the Romanian province of Moldavia. Isidore Isou's adopted name appears to have been coined in alliterative honour of the original Dadaist provocateur, Tristan Tzara, also of

Isidore Isou.

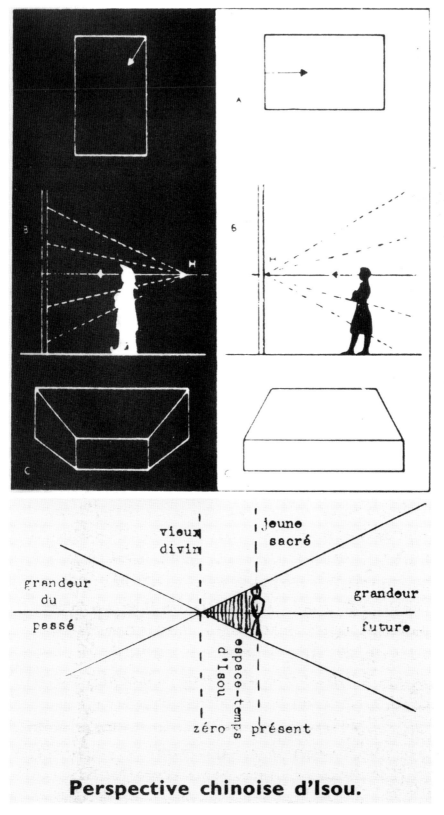

**Perspective chinoise d'Isou.**

Top and bottom:
Illustrations from
*International
Situationniste*,
no. 4, 1960.

Romanian Jewish origins. Isou arrived in France in 1945 determined to make a name for himself amongst the literati of Paris. To this end early in 1946 he

For more on the history of the group see Stephen C Foster ed., "Lettrisme: Into the Present", special issue of *Visible Language*, vol. 17, no. 3, Chicago, IL, Summer 1983.

formed the Lettriste movement with Gabriel Pomerand.[7] Isou's theory was based on a cultural process that began with an 'amplic' phase (outward looking) before being superseded by a 'chiselling' phase (inward looking, where subjects are reduced to ever smaller units of investigation). Such chiselling led to the deconstruction of words into their component parts, namely letters, as he explained in his Manifesto of Lettriste Poetry:

Destruction of words for letters.

ISIDORE ISOU: Believes in the potential elevation beyond WORDS; wants the development of transmissions where nothing is lost in the process; offers a verb equal to a shock. By the overload of expansion the forms leap up by themselves.

ISIDORE ISOU: Begins the destruction of words for letters.

ISIDORE ISOU: Wants letters to pull in among themselves all desires.

ISIDORE ISOU: Makes people stop using foregone conclusions, words.

ISIDORE ISOU: Shows another way out between WORDS and RENUNCIATION: LETTERS. He will create emotions against language, for the pleasure of the tongue. *It consists of teaching that letters have a destination other than words.*

ISIDORE ISOU: Will unmake words into their letters. Each poet will integrate everything into Everything. Everything must be revealed by letters.[8]

First published in Isidore Isou, *Introduction à une Nouvelle Poésie et une Nouvelle Musique*, Paris: Gallimard, 1947. Available in English translation at http://www.thing.net/~grist/l&d/lettrist/isou-m.htm

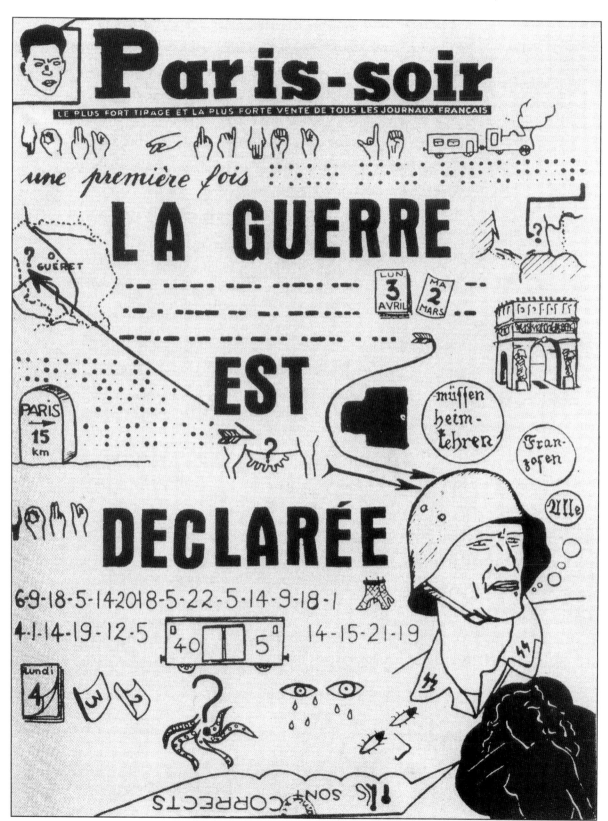

Maurice Lemaître, *Canailles!*, 1951.

19

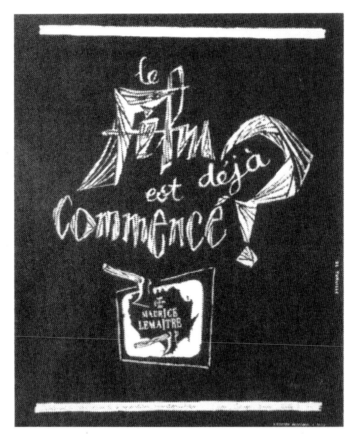

Maurice Lemaître
(with Isidor Isou,
Gil J Wolman, Marcelle
Dumont-Billaudot and
Christiane Guymer),
*Le film est déjà
commençe?*, 35mm,
1951.

Isou also explored the visual dimension of language, through the merging of poetry with modern painting–creating a form of Concrete poetry or Dada and Futurist word-collage. This technique was initially called "metagraphics", but eventually became known as "hypergraphics". The movement's other key theorist, Maurice Lemaître, described it as a synthesis of many forms of communication, as an "ensemble of signs capable of transmitting the reality served by the consciousness more exactly than all the former fragmentary and partial practices (phonetic alphabets, algebra, geometry, painting, music, and so forth)".[9]

Quote from Stephen C Foster, "Letterism: A Point of Views", in Foster ed., *Visible Language*, 1983, p. 7.

A particularly novel aspect of Isou's theory focused on the recognition of a 'youth problem'. In his text *Traité d'économie nucléaire: le soulèvement de la jeunesse* (*Treatise on Nuclear Economy: Youth Insurrection*) rebellious youths were encouraged to reject their future subservient role in society and described as the new proletariat, a potentially revolutionary class with nothing to lose. Around him he gathered his own group of young and disaffected youths including: Serge Berna, Jean-Louis Brau, François Dufrêne,

and Gil J Wolman. One of the group's earliest events was an evening of recitals at the nightclub, Le Tabou, 33 rue Dauphine in October 1950. Lettriste events took on many of the characteristics of Dada cabaret especially with its transformation of sound and meaning into noise and gibberish. Likewise the soundtrack to Isou's film, *Treatise on Slime and Eternity*, consisted of sound poetry and arbitrary noises. A year later another of his films, *Débat sur le Cinema (Debate over the cinema)*, 1952, consisted purely of the audience discussing what a film might be.

Isidore Isou, *Douze Hypergraphies*, 1964.

In April 1950, a year before Debord's arrival on the scene, the Lettristes achieved national notoriety when Berna, Michel Mourre, Ghislain Desnoyers de Marbaix and Jean Rullier disrupted Easter Mass at Notre-Dame in Paris. Dressed as a Dominican monk, Mourre delivered a blasphemous sermon written by Berna:

Verily I say unto you: God is dead. We vomit the agonizing insipidity of your prayers, for your prayers have been the greasy smoke over the battlefields of our Europe. ... Today is Easter day of the Holy Year. Here under the emblem of Notre-Dame of France, we proclaim the death of the Christ-god, so that Man may live at last.

In attempting to escape the angry and increasingly violent congregation, the four were 'rescued' by the police and Mourre was later charged with impersonating a priest.[10] It was just the kind of scandal that Debord would later seek to emulate.

The affair and resulting scandal is recounted in Greil Marcus, *Lipstick Traces: A Secret History of the Twentieth Century*, London: Secker & Warburg, 1989, pp. 279-284.

During the summer of 1951, Debord often visited Isou in Paris. In the winter he moved there permanently, ostensibly to become a law student at the Sorbonne. In his memoirs he gave the following prosaic account of his arrival:

Before the age of 20, I saw the peaceful part of my youth come to an end; and I now had nothing left except the obligation to pursue all my tastes without restraint, though in difficult conditions. I headed first towards that very attractive milieu where an extreme nihilism no longer wanted to know about nor, above all, continue what had previously been considered the use of life or the arts.[11]

Debord, *Panegyric*, London: Verso, 1991, p. 15. Translated by James Brook. Available at http://www.chez.com/debordiana/english/panegyric.htm

« Saint-Germain-des-Prés est un quartier de Paris, où les filles viennent la nuit, pour se faire violer, où chaque homme veut dépuceler la vie. La vie et les filles s'en retournent pucelles, la fleur entre les jambes, car nous sommes une génération, dont les hommes ayant trop fait la queue au cours de la récente guerre, l'ont perdue ce jourd'hui.
Mon quartier est une île qui nage sur la Seine. »

Gabriel Pommerand, extracts from *Saint-Ghetto-des-Prêts*, 1949.

On arrival in October he stayed at the hôtel de la Faculté on the rue Racine with a balcony overlooking the boulevard Saint-Michel. From here he ventured out into the local streets and bars, making contact with an 'attractive milieu' that later became known as 'the tribe'.

The tribe was made up of a small group of young people who drifted around the bars of Saint-Germain-des-Prés, avoiding work, committing petty crimes and plotting the demise of bourgeois culture. Jean-Michel Mension, a participant and later chronicler of the milieu, arrived there as a 16-year old fresh out of reform school and on the run from his family of "old communist militants". Mension and his friend subscribed to an extreme philosophy of inaction, they were 'slackers' before their time:

If someone had said ... "I want to be a famous painter", if someone had said "I want to be a famous novelist", if someone had said, "I want in whatever way to be a success", then that someone would have been tossed instantly out of the back room right through the front room onto the street. There was an absolute refusal.... We rejected a world that was distasteful to us, and we would do nothing at all within it. [12]

Mension, Jean-Michel, *The Tribe*, London: Verso, 2002, p. 129.

Debord was very much in tune with this world and added his own summation of its main article of faith when in 1953 he painted on a wall, along the rue de Seine, the phrase "Ne Travaillez Jamais!" ("Never Work!"). [13]

A photograph was later published of this graffiti in *Internationale situationniste*, (no. 8, January 1963, p. 42) with the caption "minimum programme of the Situationist movement".

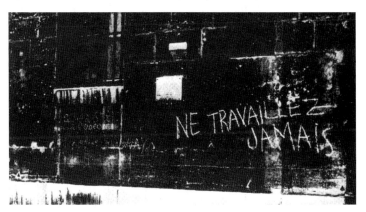

Guy Debord, graffiti, 1953.

## *Howlings in Favour of Sade* and the
## founding of the Lettriste International

It did not take Debord long to become disillusioned with the Isou-controlled Lettriste movement. In June 1952 he secretly formed, along with Berna, Brau, and Wolman, the Lettriste International tendency. Later that

---

## LETTRISTISCHE INTERVENTION

Brief an die Redaktion der „Times"

Sir,
The *Times* has just announced the projected demolition of the Chinese quarter in London.
We protest against such moral ideas in town-planning, ideas which must obviously make England more boring than it has in recent years already become.
The only pageants you have left are a coronation from time to time, an occasional royal marriage which seldom bears fruit; nothing else. The disappearance of pretty girls, of good family especially, will become rarer and rarer after the razing of Limehouse. Do you honestly believe that a gentleman can amuse himself in Soho?
We hold that the so-called modern town-planning which you recommend is fatuously idealistic and reactionary. The sole end of architecture is to serve the passions of men.
Anyway, it is inconvenient that this Chinese quarter of London should be destroyed before we have the opportunity to visit it and carry out certain psycho-geographical experiments we are at present undertaking.
Finally, if modernisation appears to you, as it does to us, to be historically necessary, we would counsel you to carry your enthusiasm into areas more urgently in need of it, that is to say, to your political and moral institutions.
Yours faithfully,

> Michèle Bernstein, G.-E. Debord, Gil J. Wolman,
> 13. October 1955
> POTLATCH

---

Letter to *The Times*, 1955.

month he also showed his first documented work of art, the film *Hurlements en faveur de Sade* (*Howlings in Favour of Sade*). In *Howlings* Debord drew on many of his fellow Lettristes ideas about cinema. He had been most particularly impressed by Wolman's *The Anticoncept*, 1952, in which the only imagery consisted of amorphous black and white shapes projected on to a sounding balloon, accompanied by a soundtrack of his apparently meaningless stream of consciousness poetry:

...grimace smile in the mirror he was seeing his
death mouths glued together we had started to vomit
to consume the acts was to forget to be free I have
my hands flat on your I crush you against the tree
standing up I look at you marvellous you make me
drunk the days of stupid girls.... [14]

An English translation of the film's soundtrack is available at the Not Bored website: http://www.notbored.org/anticoncept.html. The film was obviously so disturbing that the French film censorship commission almost immediately banned it and cancelled any further showings.

According to Andrew Hussey, the title for Debord's film came from an essay by
Georges Bataille known now as "The Lugubrious Game" but originally entitled

Hussey, *The Game of War*, 2001, p. 61.

"Howling in Favour of Dalí".[15] Debord obviously considered de Sade a more
suitable symbol of revolt than the showman Surrealist painter Salvador Dalí.
An early version of the film's scenario appeared in the one and only issue

Edited by Marc-Gilbert Guillaumin, and published in April 1952. *Ion* represented the Lettristes' main statement on cinema and included Wolman's script for *The Anticoncept*.

of the journal *Ion*.[16] The magazine also included Debord's earliest essay
"Prolégomènes à tout cinéma futur" ("Prolegomena for all Future Cinema") in
which he sets out a theme that would concern him for many years to come:
"Future arts will be the overthrow of situations, or nothing." At this stage the
film's scenario noted shots of the author in a bar and documentary footage of
riots and paratroopers, but when the film was finally completed in June 1952
these images had been removed and replaced by an alternating black and white
screen accompanied by brief snatches of dialogue read by Debord, Wolman,
Berna, Isou, and Barbara Rosenthal. This fragmented dialogue quoted Isou,
articles of law (specifically those concerning missing persons, and insanity),
passages from newspapers, quotes from James Joyce's *Ulysses*, and dialogue
from John Ford's *Rio Grande*. At one stage Wolman prophetically states:
"A science of situations is to be created, which will borrow elements from
psychology, statistics, urbanism and ethics. These elements have to coincide
in an absolutely new goal: the conscious creation of situations."[17] The

Debord, Guy, *Society of the Spectacle and Other Films*, London: Rebel Press, 1992, p. 14.

film ended with the statement "We live like lost children, our adventures
incomplete" followed by 24 minutes of complete darkness. Not only was this
a film about situations, it was also designed to create one.

Its first screening took place on 30 June 1952, at the Avant-Garde
Film Club, directed at that time by Armand J Cauliez. The film was soon halted,
however, when the audience was split between those that walked out and those
that threatened to attack Debord and his friends. Its first complete showing

took place on 13 October at the Ciné-Club du Quartier Latin where this time Debord came prepared with a bodyguard made up of his friends. A month later the same gang halted a showing of *Sadistic Skeleton* by somebody calling themselves "René-Guy Babord". According to Debord the night was intended to be a joke at his expense consisting solely of somebody turning out all the lights in the cinema for a quarter of an hour.[18] In June 1957 when the film was shown at the ICA in London the program notes warned:"The Institute is screening this film in the belief that members should be given a chance to make up their own minds about it, though the Institute wishes it to be understood that it cannot be held responsible for the indignation of members who attend."

See Guy Debord, "Technical Notes on the First Three Films", in Guy Debord, *Complete Cinematic Works: Scripts, Stills, Documents*, Edinburgh and Oakland, CA: AK Press, 2003, p. 211.

Again it caused a near riot as spectators leaving the cinema tried to convince those queuing up for the second showing to go home or ask for there money back. This, of course, just made the film more intriguing for those waiting outside and they became even more determined to see exactly what all the fuss was about.[19]

Atkins, Guy (with the help of Troels Andersen), *Asger Jorn: The Crucial Years. 1954-1964*, London: Lund Humphries, 1977, pp. 57-8.

Debord and his friends finally split with the main Lettriste movement after Isou's disapproving reaction to their involvement in a small scandal concerning a press conference held by Charlie Chaplin at the Ritz Hotel in Paris on 29 October 1952. For this special occasion Debord and his closest allies, Berna, Brau and Wolman, gate crashed the event and distributed their scathing polemic entitled "No More Flat Feet!". The text described Chaplin as an "emotional blackmailer" and denounced him as "he-who-turns-the-other-cheek". For Debord and co. ("the young and the beautiful"), the only answer to suffering was revolution. They end graciously: "Go to sleep, you fascist insect. Rake in the dough. Make it with high society (we loved it when you crawled on your stomach in front of little Elizabeth). Have a quick death: we promise you a first-class funeral."[20]

Reproduced in Marcus, *Lipstick Traces*, 1989, pp. 340-1. Translated by Sophie Rosenberg. First published as: Serge Berna, Jean-Louis Brau, Guy-Ernest Debord & Gil J Wolman, "Finis les pieds plats", *Internationale lettriste*, no. 1, November 1952.

Isou's faux-pas was to denounce the demonstration in the pages of *Combat*, France's daily newspaper of the non-communist left. Debord and his friends replied that "the most urgent expression of freedom is the destruction of idols, especially when they claim to represent freedom". The gap between them and Isou was what separated "extremists from those who no longer stand close to the edge". Isou would henceforth be abandoned to the "anonymous crowd of the easily offended".[21] Thus occurred Debord's first exclusion, albeit

Marcus, *Lipstick Traces*, 1989, pp. 341-3.

an indignant self-exclusion. Debord had learnt much from Isou, especially about the intransigence and megalomania necessary to lead an avant-garde movement. However, the cult of personality and publicity that Isou encouraged and craved were anathema to Debord. His leadership style drew on a reading of Machiavelli and revealed a preference for acting as a background figure, influencing events from the shadows. With Isou debunked Debord found himself with only one option to pursue: a new movement must be formed.

The Lettriste International (LI) was formally convened at the Aubervilliers Conference on 7 December 1952. A handwritten constitution was produced stating the rule of majority decision making, the principle of "the transcendence of the arts", the exclusion of anybody collaborating with Isou and his colleagues, and the exclusion of anybody "publishing a commercial work under their name".[22] Reproduced in Mension, *The Tribe*, 2002, pp. 52-3. One would-be member, Jean-Michel Mension, missed out on this momentous occasion because of his arrest for drunkenness. Incarceration and black-outs were an occupational hazard for members of 'the tribe'. Debord would often boast about his talent for drinking, a talent first developed in Saint-Germain-des-Prés:

Among the small number of things that I have liked and known how to do well, what I have assuredly known how to do best is drink. Even though I have read a lot, I have drunk even more. I have written much less than most people who write; but I have drunk much more than most people who drink.[23]

Debord in *Panegyric*, 1991.

The first meetings of the tribe took place in Café de Mabillon and The Old Navy, but when these places became too popular they moved on to Chez Moineau, a little bistro at 22 rue du Four.[24] It was Parisian café society, but sleazy back streets away from the tourist-thronged boulevards leading to the celebrity existentialists at Café de Flore and Deux-Magots. Despite these tourists the area remained attractive to artists from around the world. One such artist, Ralph Rumney, had first gravitated there in 1952 whilst on the run from National Service. He was born in 1934 in Newcastle-Upon-Tyne but spent his childhood in Halifax, Yorkshire. His father, an ex-miner turned vicar,

Debord and Michèle Bernstein obviously loved this world so much that on 10 October 1958 they opened their own bar, La Méthode, on the rue Descartes. Bernstein provided the main impetus for the enterprise and the funding came from her father. Pinot-Gallizio provided some artworks and Bernstein's friend Florencie was booked to sing each night. It was great while it lasted, but it didn't last long: it closed just a few weeks later.

Top and bottom:
Ralph Rumney, *Front and back*, acrylic on newspaper, c. 1957, Courtesy: Manchester University Press. Photo: Alan Ward.

brought him up alone, after his mother died when he was just 14. Rumney's first experience of scandal occurred when he requested to see a book by the Marquis de Sade in his local library. After just six months at Halifax School of Art he moved to Cornwall and worked as an assistant to the sculptor Barbara Hepworth. He moved to Paris in the spring of 1952 and immersed himself in the dissolute world of the Moineau tribe, forming close friendships with

Ralph Rumney, *Head on the Floor*, c. 1962
Courtesy: Manchester University Press.
Photo: Alan Ward.

Debord, Francois Dufrêne and Jean-Claude Guilbert. It was also here that
Rumney picked up his nick-name, "The Consul", after the main character in
Malcolm Lowry's influential study of alcohol and madness, *Under the Volcano*:
"When I was young I drank enough to go mad", Rumney said, echoing one
of Debord's many eulogies to alcohol. "Now, after a rather difficult period, I
drink with the moderation of the extremist."[25]

Rumney, Ralph, *The Consul*, London: Verso, 2002, p. 112.

Many of the ideas that would later be adopted by the SI were first
developed by the LI. At this time the group featured a loose cast of shadowy
figures–some known for signing texts they never read–including Pierre-Joël
Berlé (who ended up a mercenary in Kantanga), René Leibé, Gaëtan M Langlais,
and Mohamed Dahou (part-time guitarist and alleged hash dealer). More
seasoned avant-gardists from the Lettriste movement included Wolman, Brau,
and Berna. The group spent much of its time hustling for enough money to
spend that night in Moineau's. Here they would sing, play chess, and argue

about the latest cultural trends. The group also included many women, amongst

them were Barbara Rosenthal, Sarah Abouaf, the Australian Vali Myers, Paulette

Brau, of mixed Hungarian and Spanish origin, was first Debord's girlfriend, then she married Mension, then Jean-Louis Brau. She later wrote the book *Le Situationnisme ou la nouvelle internationale*, Paris: Debresse, 1968.

Vielhomme, and Éliane Brau (at that time known as Éliane Papaï).[26] Not least

amongst the women involved with the LI were Old Madame Moineau and

the waitress Marithé, who together ran Chez Moineau and sympathetically

accommodated the often unruly tribe at their tables.

Another key member of the LI was Michèle Bernstein.

Although born in Paris in 1932, she spent most of her childhood

in Normandy. Her father was of Russian-Jewish origin but by the time

of the Nazi occupation of France her parents had long been divorced

Michèle Bernstein, c. 1958.

For more biographical information on Bernstein see Marcus, *Lipstick Traces*, 1989, pp. 373-8.

and her mother was remarried.[27] Bernstein returned to Paris in the early-1950s

to study at the Sorbonne, but she soon found a more interesting education

amongst the tribe at Chez Moineau. It was here in 1952 that she first met

Debord. The two fell in love and married in August 1954, without the knowledge

They remained married up to their divorce on 5 January 1972. The story of their courtship is told in Hussey, *The Game of War*, 2001, pp. 95-7, as is their divorce on p. 282.

of their parents.[28]

Over the next few years she subsidised Debord, the LI and SI through

a variety of jobs, including spells as a horse race forecaster, horoscope writer,

publisher's assistant at Éditions de Navarre and, most ironically, an advertising

director. Bernstein also wrote two novels–*Tous les chevaux du roi* (*All the King's*

*Horses*) and *La Nuit* (*The Night*)–the first with a plot based on Marcel Carné's

film *Les Visiteurs du soir* (*The Devil's Envoys*), 1942, and written in the style of

an 'existentialist' novel, and the second with a similar plot, but this time

The books were published in 1960 and 1961 respectively, both by Buchet-Chastel, who would later publish the first edition of Debord's *The Society of the Spectacle* in 1967.

written in the style of the then fashionable *Nouveau Roman*.[29] Both took place

in milieus remarkably similar to that of the LI and both included characters

resembling Bernstein (Geneviève) and Debord (Gilles) and their increasingly

'open' relationship. In *All the King's Horses* a young woman and lover, Carol,

asked Gilles about his work:"What do you do, exactly? I have no idea."

"I reify", he answered. "It's a serious job", [Geneviève] added. "Yes, it is", he

said. "Oh", Carol observed with admiration. "Serious work, with big books and

The novels are not, at the time of writing, available in English translation. However, the first few chapters have been translated by John Kelsey and published in pamphlets issued by Reena Spaulings Fine Art, 371 Grand Street, Lower East Side, New York in 2004.

a big table cluttered with papers." "No", said Gilles. "I walk. Mostly I walk."[30]

When not walking Debord and Bernstein favoured random rides around

Paris in taxis. In an article from 1954 Bernstein applauded proposals to ban

private vehicles from the centre of Paris but bemoaned the set routes of the

Metrobus. The solution, she suggested, was for everybody to use taxis:

Only taxis allow true freedom of movement. By travelling varying distances in a set time, they contribute to automatic disorientation. Since taxis are interchangeable, no connection is established with the "traveller" and they can be left anywhere and taken at random. A trip with no destination, diverted arbitrarily en route, is only possible with a taxi's essentially random itinerary.[31]

Bernstein, Michèle, "Dérive by the Mile", *Potlatch*, no. 9-10-11, August 1954. Translated at Situationist International Online http://www.cddc.vt.edu/sionline/index.html

Michèle Bernstein, 1963.

Fortunately for the tribe–and history–the Dutch photographer Ed Van der Elsken stumbled upon the group one night during a chance visit to Moineau's. His semi-documentary photographs from this time were later collected together in the innovative photo-novel *Love on the Left Bank*,1957.[32]

van der Elsken, Ed, *Love on the Left Bank*, London: André Deutsch, 1957. Some of these images would also find their way into Debord's own book on this period, *Mémoires*, 1959.

One photograph by Elsken showed Mension posing with 'Fred' (real name Auguste Hommel) in his dirty white painter's trousers scrawled with LI slogans, "l'Internationale lettriste ne passera pas" ("The Lettrist International will never pass"), and the title of Debord's film, *Hurlements en faveur de Sade* (*Howlings in favour of Sade*).[33] Quite soon after Mension posed for Elsken Debord excluded him from the LI for being, as he put it, "merely decorative".[34] Mension's exclusion was not the only one to take place during 1953. Also out went Berna for "lack of intellectual rigor" and Brau for "militarist deviations". To further establish this new order a different bar, Le Tonneau d'Or at 32 rue Montagne-Sainte-Geneviève, became the headquarters.[35]

Over 20 years later Malcolm McLaren and Vivienne Westwood rejuvenated this practice with their Seditionairies shirts and T-shirts, covered with slogans such as "Be reasonable, demand the impossible", "Only anarchists are pretty" and "A bas le Coca Cola".

See Mension, 2002, p. 91. The photograph of Mension and Fred can be found on p. 89.

Always listed as Montagne-Geneviève in LI publications because, for the deeply anti-religious Debord, saints should never be acknowledged, even in print.

Auguste Hommel and Jean-Michel Mension, Paris, 1953. © Ed van der Elsken/Nederlands fotomuseum.

## *Potlatch*, **Psychogeography**, *Dérive*, and *Détournement*

In time-honoured fashion the LI promoted its activities and philosophy through the pages of its own newsletter, named matter-of-factly *Internationale Lettriste*. Four issues appeared between 1952 and 1954 before it was superseded on 22 June 1954 by the first issue of *Potlatch*, subtitled: "The Bulletin of Information of the French group of the Lettriste International". Its mimeographed pages were typed up by Bernstein and edited in succession by André-Frank Conord (no. 1-8), Mohamed Dahou (no. 9-18), Wolman (no. 19), Dahou again (no. 20-22), and Jacques Fillon (no. 23-24).[36] Only 50 copies of the first issue were printed, but from

All issues were later collected together in: Guy Debord ed., *Potlatch: 1954-57*, Paris: Éditions Gérard Lebovici, 1985.

then onwards 400 copies of each edition were distributed. It carried no cover price, and could not be found for sale in any newsagents–its means of circulation was simply as a gift. The journal quickly became the main source, a kind of laboratory of ideas, for what would become the main tenants of the SI. In its pages you will find the first mention of concepts such as psychogeography, *dérive*, *détournement*, and unitary urbanism.[37] As well as introducing these concepts the journal carried concise and informative articles alongside a fair share of wackily utopian proposals. One example of the latter was the suggestion that street lights should have switches on them so that local residents could control them. Another was that museums should be pulled down and their contents distributed amongst the clientele of various bars.[38] The title of the journal, *Potlatch*, drew on the work of the anthropologist Marcel Mauss and his study, *The Gift*, which looked at the exchange of gifts, from canoes to hunting rights, amongst the native American tribes of British Columbia and

In a useful footnote Simon Sadler states that "psychogeography" was first mentioned in *Potlatch*, no. 1 (June 1954); "*détournement*" in no. 2 (June 1954), "*dérive*" in no. 9-10-11 (August 1954); "situation" in no. 14 (November 1954), and "unitary urbanism" in no. 27 (November 1956). See Simon Sadler, *The Situationist City*, Cambridge, MA: MIT Press, 1998, p. 168.

See Anon, "Plan For Rational Improvements to the City of Paris", in Libero Andreotti and Xavier Costa eds., *Theory of the Dérive and Other Situationist Writings on the City*, Barcelona: Museu d'Art Contemporani de Barcelona; ACTAR, 1996, pp. 56-7. First published in *Potlatch*, no. 23, 13 October 1955.

Mauss, Marcel, *The Gift: Forms and Functions of Exchange in Archaic Societies*, London: Routledge & Kegan Paul, 1954.

Alaska.[39] Potlatch described the enhancement of status through ceremonial gift-giving or festive destruction. As a theory of economic exchange based on sacrifice and excess, it attracted the attention of, amongst many others, George Bataille.[40] Most likely, the LI became aware of the concept through Bataille's writings and agreed with his positive analysis of the practice as an exemplary subversion of the concept of exchange value in an act of unproductive expenditure.[41]

See his "Notion of Expenditure" in: Georges Bataille, *Visions of Excess: Selected Writings 1927-1939*, Manchester: Manchester University Press, 1985.

For more on Bataille and the LI see: Hussey, *The Game of War*, 2001, p. 84-7.

The LI's fascination with urban living and chance encounters led

This focus on urbanism was undoubtedly linked to the phenomenon of migration from the country to the city then profoundly affecting France and all the major urban conurbations of Europe. For example, in 1954 five million French workers were employed in agriculture and forestry. By 1963 this had dropped to 3.65 million and in 1968 to 2.9 million. See Arthur Marwick, *The Sixties: Cultural Revolution in Britain, France, Italy, and the United States, c.1958-c.1974*, Oxford: Oxford University Press, 1998, p. 257.

to a number of key discoveries.[42] For the LI the city had to be reinvented on a personal level, to be reconfigured along the lines of a new nomadic lifestyle. Historical precedents included Baudelaire's description of the flâneur and De Quincey's drug-addled wanderings around the back streets of Manchester and London. The LI named its studies in this area psychogeography and by way of illustration Debord wrote in the second issue of *Potlatch* that the 18th century Italian architect and draughtsman Giovanni Battista Piranesi was "psychogeographical in the stairway"; the painter Claude Gelée (Lorraine) was "psychogeographical in the juxtaposition of a palace neighbourhood and the sea"; the French postman and 'outsider' artist Ferdinand Cheval was "psychogeographical in architecture"; Jack the Ripper was "probably psychogeographical in love" and Saint-Just was "a bit psychogeographical

Debord, Guy, "Exercise in Psychogeography" in Andreotti and Costa, *Theory of the Dérive*, 1996, p. 42. First published in *Potlatch*, no. 2, 29 June 1954.

in politics (Terror is disorienting)".[43] By 1958, and after four years of honing and experimentation, a precise definition was provided: "Psychogeography. The study of the specific effects of the geographical environment, consciously organised or not, on the emotions and behaviour of individuals." The word "psychogeographical" described that which "manifests the geographical environment's direct emotional effects" and a psychogeographer was simply

Anon, "Definitions", in Andreotti and Costa, *Theory of the Dérive*, 1996, p. 69. First published in: *Internationale situationniste*, no. 1, June 1958, pp. 13-14.

"one who explores and reports on psychogeographical phenomena".[44]

The chief means of psychogeographical investigation was the *dérive*, which consisted of drifting and deliberately trying to lose oneself in the city. The Surrealists provided a precedent for such journeys, with their aimless excursions dictated by chance, but the LI took this activity to new heights of seriousness and commitment with much less dependence on random factors. A *dérive* could last from anything from an hour to three or four months (Ivan Chtcheglov recommended the latter). In *Theory of the Dérive*, Debord outlined its main elements:

In a *dérive* one or more persons during a certain period drop their usual motives for movement and action, their relations, their work and leisure activities, and let themselves be drawn by the attractions of the terrain and the encounters they

find there. ... From the *dérive* point of view cities have a psychological relief, with constant currents, fixed points and vortexes which strongly discourage entry into or exit from certain zones.[45]

Debord, Guy "Theory of the Dérive", in Andreotti and Costa, *Theory of the Dérive*, 1996, p. 22. First published in *Les Lèvres Nues*, no. 8, 1956.

By 1958 the *dérive* had been more simply defined as a "mode of experimental behaviour linked to the conditions of urban society: a technique of transient passage through varied ambiences. Also used to designate a specific period of continuous deriving".[46]

Anon, "Definitions", in Andreotti and Costa, *Theory of the Dérive*, 1996, p. 69.

An account of two early *dérives* appeared in *Les Lèvres Nues*, a Surrealist-influenced journal edited by the Belgian poet Marcel Mariën in Brussels. The first took place on the evening of 25 December 1953 and the second on 6 March 1956. Debord's account of the first *dérive* was more about the people they met than the environments they passed through. Drifting from bar to bar they meet Algerians, West Indians, and Jewish people and

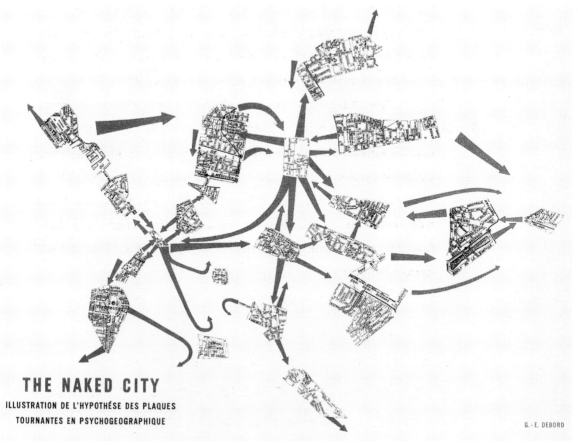

**THE NAKED CITY**

ILLUSTRATION DE L'HYPOTHÉSE DES PLAQUES
TOURNANTES EN PSYCHOGEOGRAPHIQUE

G. - E. DEBORD

Guy Debord, *The Naked City*, 1958

become involved in real and imaginary pursuits and close escapes. For the second *dérive* he was accompanied by Wolman and after meeting at the rue des Jardines they headed north:

Despite their intentions they quickly find themselves drifting toward the east and traversing the upper section of the 11th arrondissement, an area whose poor commercial standardisation is a good example of repulsive petit-bourgeois landscape. The only pleasing encounter is the store at 160, rue Oberkampf: "Delicatessen-Provisions A. Breton".

The journey continued into the 20th arrondissement where they discovered an important psychogeographic hub near the canal Saint-Martin. It ended in Aubervilliers in a Spanish bar known as the "Tavern of the Revolters".[47]

Debord, Guy, "Two Accounts of the Dérive", in Sussman, *On the passage*, 1989, pp. 135-9. First published in *Les Lèvres Nues*, no. 9, November 1956.

Debord and Wolman also chose *Les Lèvres Nues* to promote their theory of *détournement*.[48] In "A User's Guide to Détournement" they described the process as involving the transformation of both everyday ephemera, such as advertisement slogans and comic strips, and significant cultural products, such as quotations from Marx and old master paintings. These would then be re-presented within a new artistic context:

There is no single word in English that could stand as a direct translation. *Détournement* carries with it something of the following meanings: diversion, rerouting, corruption and hijacking.

*Détournement* not only leads to the discovery of new aspects of talent; in addition, clashing head-on with all social and legal conventions, it cannot fail to be a powerful cultural weapon in the service of a real class struggle. The cheapness of its products is the heavy artillery that breaks through all the Chinese walls of understanding. It is a real means of proletarian artistic education, the first steps towards a literary communism.[49]

Debord, Guy and Gil J Wolman, "A User's Guide to *Détournement*" in Debord, *Complete Cinematic Works*, 2003, p. 209. First published in *Les Lèvres Nues*, no. 8, 1956.

Once again the term found its full Situationist definition two years later in 1958 as the

*détournement* of pre-existing aesthetic elements. The integration of present or past artistic production into a superior construction of a milieu. In this sense there can be no situationist art or music, but a situationist use of these means. In a more primitive sense, *détournement* within the old cultural spheres is a method of propaganda, a method which testifies to the wearing out and loss of importance of those spheres.[50]

Anon, "Definitions", in Andreotti and Costa, *Theory of the Dérive*, 1996, p. 70.

As a form of creative plagiarism there was little in *détournement* that was particularly novel, except perhaps, its new name and the extravagant claims for its effectiveness. Precursors can be found in the collage work of the Dadaists, the Surrealists and, more closer to home, the word, letter and pictogram collages of the Lettristes. Lautréamont's famous declaration also provides a literary precedent: "Plagiarism is necessary. It is implied in the idea of progress. It clasps an author's sentence tight, uses his expressions, eliminates a false idea, replaces it with the right idea."[51] *Détournement*, therefore,

Lautréamont, *Maldoror and Poems*, Harmondsworth: Penguin Books, 1978, p. 274.

extended beyond the visual arts and into the literary and philosophical realm, with Debord's texts (and later his films), often being liberally sprinkled with *détourned* quotations from his favourite authors. *Détournement* can be seen, therefore, as an extreme form of the redistribution of cultural value.

## Asger Jorn, Cobra, and The International Movement for an Imaginist Bauhaus

Even at this early stage Debord held few illusions about the ultimate worth of art. "A User's Guide to Détournement" opened with the unequivocal statement that:

Every reasonably aware person of our time is aware of the obvious fact that art can no longer be justified as a superior activity, or even as a compensatory activity to which one might honourably devote oneself. The reason for this deterioration is clearly

the emergence of productive forces that necessitate other production relations and a new practice of life.[52]

Debord, Guy and Gil J Wolman, "A User's Guide to *Détournement*" in Debord, *Complete Cinematic Works*, 2003, p. 207.

Such an attitude, however, did not preclude his association with individuals pursuing a less absolutist path. Collaboration between the LI and the Belgian surrealists associated with *Les Lèvres Nues*, proved the first step in expanding the field of a new practice of life beyond the back streets of Saint-Germain-des-Prés. These contacts plus the increasing popularity of *Potlatch* soon brought the LI to the attention of other avant-garde artists seeking similar aims. One of these artists, Asger Jorn, was to become an essential figure in the foundation of the SI.

Asger Jorn was born Asger Jørgensen in the small village of Vejrum in North Jutland in 1914. During his studies at a teacher training college in Silkeborg he joined the Communist party and came under the influence of the widely respected Syndicalist, Christian Christensen. In 1936 he travelled to Paris to study art, and spent ten months as a student of the painter Ferdinand Léger

Asger Jorn.

at his Atélier de l'art contemporain. He returned to Demark just before the start of the Second World War. During the German occupation he joined the Communist resistance movement and helped with the printing of an underground newspaper. After the war he returned to Paris and became a member of the Revolutionary Surrealist Group (RSG) formed in Brussels as an antidote to Breton's growing opposition to the Communist Party. When the RSG broke up he became a founding member of Cobra, signing the 1948 declaration *Le Cause était entendue* (*The Case is Closed*) along with Karel Appel, Guillaume Corneille, Christian Dotremont, Constant Nieuwenhuys and Joseph Noiret.

The group's curious name derived from the initial letters of three European cities: Copenhagen, Brussels, and Amsterdam (significantly providing a decentralised network, distinct from the then dominant position of the Parisian art world). These cities were closely associated with the group's main protagonists: Jorn with Copenhagen, Corneille and Dotremont with Brussels, and Constant and Appel with Amsterdam. The Cobra artists soon

became known for their colourful and violently expressionist brushwork, their depiction of mythological or folkloric themes, and their interest in the so-called 'outsider' art of children and the insane. These styles and influences were combined with a broadly Marxist viewpoint. Constant in particular often expressed his pursuit of a radical social vision based upon experiment and revolutionary consciousness:

Any real creative activity–that is, cultural activity, in the twentieth century–must have its roots in revolution. Revolution alone will enable us to make known our desires, even those of 1949. The revolution submits to no definition! Dialectical materialism has taught us that conscience depends upon social circumstances, and when these prevent us from being satisfied, *our needs impel us to discover our desires.*[53]

Constant, "Our Own Desires Build the Revolution", in Charles Harrison and Paul Wood eds., *Art in Theory: 1900-2000: An Anthology of Changing Ideas*, Cambridge: Blackwell Publishing, 2003, pp. 659-660. First published in *Cobra*, no. 4, 1949, p. 3.

Some exhibitors at the IMIB laboratory, Alba, 1956. From left to right: Ettore Sottsass, Gil J Wolman, Asger Jorn, Constant, Elena Verrone. Photo: Archivio Gallizio, Turin.

Whilst a member of Cobra, Jorn added his own brand of faux naïve draughts-manship, violent gestural brushstrokes and bright colouration. His intellectual foundations drew on his studies of Scandinavian romanticism (especially the theologians Emanuel Swedenborg and Søren Kierkegaard), libertarianism and Marxism. Not surprisingly, given such a variety of

Pinot Gallizio and
his son Giors
Melanotte with
industrial paintings in
the laboratory, Alba,
1959. Photo: Archivio
Gallizio, Turin.

influences, Cobra never formed a coherent theoretical base for its activities
and by 1951 internal disputes of both a political and personal nature led
to its dissolution.[54]

At this point Jorn's health, ravaged by tuberculosis and malnutrition,
had deteriorated to such an extent he returned to Silkeborg for a period of
recuperation. After a few months of rest he was once again travelling through
Europe and recruiting members for his latest art movement. The International
Movement for an Imaginist Bauhaus (IMIB) was set up in Switzerland in
1953 by Jorn and fellow artists Appel and Corneille from Cobra, and new allies,
Italian artists Enrico Baj and Sergio Dangelo, from the Nuclear Art movement,
itself formed just a year before. The group never really developed beyond
being a loose amalgamation of artists united in its opposition to the new
Bauhaus then being set up by Max Bill in Ulm, Germany. Jorn thought Bill
was corrupting and misrepresenting the original ideals of the Bauhaus in

For documents by Cobra members most closely related to the foundation
of the SI see: Gérard Berréby ed.,
Documents relatifs à la fondation
de l'Internationale situationniste:
1948-1957, Paris: Éditions Allia,
1985. For a general introduction to
Cobra see: Willemijn Stokvis, Cobra:
The Last Avant-Garde Movement of
the Twentieth Century, Aldershot:
Lund Humphries and V+K Publishing,
2004.

favour of his own brand of rationalism and functionalism. The IMIB was against the formal abstraction and industrial aesthetic of this new Bauhaus and believed more attention should be paid to subjectivity, experimentation, automatism and chance. Rather than being used to enslave artists, machines should be used for creative purposes. In answer to a question about the function of the IMIB Jorn wrote: "It is the answer to the question *where and how* to find a justified place for artists in the machine age." His solution was to treat artistic research as identical to 'human science' and to this end he encouraged artistic collaboration with scientists. "Our practical conclusion is the following", he wrote, "we are abandoning all efforts at pedagogical action and moving toward experimental activity".[55]

Jorn, Asger, "Note on the Formation of an Imaginist Bauhaus", 1957, in Andreotti and Costa, *Theory of the Dérive*, 1996, pp. 35-6.

The IMIB laboratory in Alba, 1956. From left to right: Constant, Piero Simondo, Gil J Wolman, Asger Jorn. Photo: Archivio Gallizio, Turin.

To this end, in 1955, Jorn travelled to Alba, a small Piedmontese city, to help set up the Imaginist laboratory. His collaborator on this project was Giuseppe Pinot-Gallizio, an older artist with wide and varied experience as a chemist, pharmacist, aromatologist, archaeologist, and local politician. Together, and with the help of Pinot-Gallizio's son Giors Melanotte, they turned the studio–a 30 metre long space in a seventeenth century monastery–into the group's laboratory. In 1956 Gallizio edited the IMIB's first and last issue of its journal *Eristica*, with texts by Jorn and new members, the Italian artist Piero Simondo and his soon to be wife Elena Verrone, plus documentation of Jorn's work exhibited at the International Ceramics Meeting in Albisola in 1954.[56]

See *Eristica*, no. 1, July 1956. The editorial committee consisted of Baj, Dotremont, and Walter Korun.

# First World Congress of Free Artists (1956)

Jorn first became aware of the LI when Enrico Baj lent him a copy of *Potlatch*. He instantly recognised the group as kindred spirits and was soon in regular correspondence with Debord. One topic of discussion was the forthcoming and grandly titled "First World Congress of Free Artists" organised by Jorn, Simondo and Pinot-Gallizio and due to take place in Alba during the first week of September 1956. Wolman represented the LI at Alba, while Jorn, Pinot-Gallizio, Simondo, and Verrone represented the IMIB. Unaffiliated artists came from throughout Europe and included Constant, Baj, Jacques Calonne, Ettore Sottsass Jr, Walter Olmo, Franco Garelli, Sandro Cherchi, Franco Assetto, and two Czech artists Pravoslav Rada and Jan Kotik (who, because of visa problems, did not make an appearance until the final day of the Congress). According to *Potlatch*, Baj was excluded almost immediately: "Confronted with his conduct in certain previous affairs,

Anon, "The Alba Platform" in Knabb, *SI Anthology*, 1981, p. 14. First published in *Potlatch,* no. 27, 2 November 1956.

Baj withdrew from the Congress. He did not make off with the cash-box."[57] (But he did resign immediately from the IMIB). Less controversially, Jorn and Gallizio curated an exhibition of Futurist ceramics, held at Alba's town hall, while the Experimental Laboratory put on a group show at the local Corino Cinema.

Left:
Pinot-Gallizio presents a paper at the First World Congress of Free Artists, Alba, 1956. From left to right: Enrico Baj, Piero Simondo, the Syndicate of Alba Cognasso, Asger Jorn. Photo: Archivio Gallizio, Turin.

Right:
Munich Conference. From left to right: Constant, Pinot-Gallizio and Jorn.

The conference opened with Jorn delivering a typically inspiring inaugural speech in which he set out his demanding programme for the contemporary avant-garde:

There are two conditions that apply for a movement to be called avant-garde. In the first place it must be isolated, without direct support from the established order, and given over to an apparently impossible and useless struggle. ... Next, the struggle of this group must be of essential importance for the forces in whose name it struggles–in our case, human society and artistic progress–and the position conquered by this avant-garde must later be confirmed by a more general development.[58]

Jorn, Asger, "Opening Speech of the First World Congress of Free Artists" in Andreotti and Costa, *Theory of the Dérive*, 1996, p. 38.

Wolman's contribution was a statement promoting unitary urbanism:

Whatever prestige the bourgeoisie may today be willing to accord fragmentary or deliberately retrograde artistic tendencies, creation can now be nothing less than a synthesis aiming at an integral construction of an atmosphere, of a style of life. ... A unitary urbanism —the synthesis that we call for, incorporating arts and technology—must be created in accordance with new values of life, values which it is henceforth necessary to distinguish and disseminate.[59]

Anon, "The Alba Platform" in Knabb, *SI Anthology*, 1981, p. 15. First published in *Potlatch*, no. 27, 2 November 1956.

The conference ended with the signing of a six point declaration agreeing on firstly the necessity of unitary urbanism; the "inevitable outmodedness of any renovation of an art within its traditional limits"; the "recognition of an essential interdependence between unitary urbanism and a future style of life" within the context "of a greater real freedom and a greater domination of nature"; and "the unity of action among the signers on the basis of this programme".[60] The last point was merely a formal expression of mutual

Anon, in Knabb, *SI Anthology*, 1981, p. 15.

support. At the end of the conference, in a gesture of collaborative good-will, Wolman was invited onto the editorial board of *Eristica* and Jorn joined the board of directors of the LI.

The LI hailed the congress as a great success and compared it to other examples of recent revolutionary events such as the Algerian insurrection against French rule, the proletarian uprisings in the USSR, Poland and Hungary, and the major strikes taking place in Spain. "These developments", they wrote, "allow us the greatest hopes for the near future".[61] Outside the LI, Pinot-Gallizio described the Congress in his diary as "an enormous and unknown chemical reaction".[62]

*Potlatch*, no. 27, November 1956.

Bandini, Mirella, "An Enormous and Unknown Chemical Reaction: the Experimental Laboratory in Alba" in Sussman, *On the passage*, 1989, p. 71.

# Early Years

## chapter two

# of the Situationist International 1957–1965

# "Report on the Construction of Situations" and the Cosio d'Arroscia Conference (1957)

By the start of 1957 preparations were already in place for the foundation of the SI. Debord's first step had been to jettison those from the LI that he considered as possible liabilities within the new organisation. In such matters he was ruthless and long established friendships counted for nothing in the expulsion of both Jacques Fillon, a former editor of *Potlatch*, and Wolman. The reason given for Wolman's exclusion was for living "a ridiculous lifestyle, cruelly underlined by ideas which became every day more stupid and narrow-minded". *Potlatch* announced his exclusion in the form of an obituary:

Wolman had an important role in the organisation of the Lettriste Left-wing in 1952, then in the foundation of the LI. Author of "megapneumic" poems, a theory of "cinematochronicity" and a film, he was Lettriste delegate at the congress of Alba in September 1956. He was 27 years old.[1]

Quoted in Hussey, *The Game of War*, 2001, p. 111.

Other issues occupying Debord's mind at this time was his possible contribution to an exhibition organised by Jorn in February at the Taptoe Gallery in Brussels. Grandly named the First Exhibition of Psychogeography it was intended to be a group exhibition bringing together members of the IMIB, the LI, the London Psychogeographical Committee (LPC) and the French artist Yves Klein. In the end the only participants were Jorn, Klein and the sole member of the LPC, Ralph Rumney. After his Paris sojourn, Rumney had returned to London with a strengthened resolve to make a name for himself as a painter. By 1953 he had started his own avant-garde magazine, *Other Voices*, and his semi-abstract paintings were attracting favourable reviews from critics and attention from collectors. After his first one-person show in 1956 at the Galleria Apollinaire in Milan and an exhibition at the New Vision Centre Gallery in London, the prestigious Redfern Gallery offered him a modestly lucrative contract. A year later he participated, alongside such respected figures as Patrick Heron and Ben Nicholson, in an important

exhibition *Metavisual, Tashiste, Abstract* curated by the art critic and historian Denys Sutton at the Redfern Gallery. The exhibition confirmed Rumney's position amongst the most progressive painters in Britain and established clear links between his work and the wider international art scene, especially Abstract Expressionism in the United States and Tachisme in France.[2]

See Fiona Gaskin, "British Tachisme in the Post-War Period, 1946-1957", in Margaret Garlake ed., *Artists and Patrons in Post-War Britain*, Aldershot: Ashgate, 2001, pp. 17-46.

     Debord's eventual decision to decline the invitation to the Brussels show may have been due to his distrust of Klein's entrepreneurial mysticism. In the meantime he kept himself busy writing the text that would provide the blueprint for the SI's first phase of existence. The "Report on the Construction of Situations and on the Terms of Organization and Action of the International Situationist Tendency" was Debord's longest and most considered text to date and its scope and ambition went far beyond providing an agenda for discussion amongst the various individuals and organisations interested in joining the new group. The key term "situation" derived in part from the existentialism of Jean-Paul Sartre. Linked to his theories about freedom of choice and responsibility, Sartre's 'situation' described a sense of self-consciousness of existence within a particular environment or ambience. The new "science of situations" expounded by Debord entailed not the passive acceptance but the active creation of these situations. In the report this "central purpose" was described as "the concrete construction of temporary settings of life and their transformation into a higher,

Debord, Guy "Report on the Construction of Situations and on the Terms of Organization and Action of the International Situationist Tendency", in Tom McDonough, *Guy Debord and the Situationist International: Texts and Documents*, Cambridge, MA and London: MIT Press, 2002, p. 44.

passionate nature".[3] In addition to looking forward to the programme of the SI, Debord used a large part of the report to critique the role of the historical avant-garde in culture. Bourgeois society, Debord argued, channeled critical and experimental research through these avant-gardes into specific disciplines and away from a total critique of all social conditions. Within these fields exceptional individuals were acceptable as long as their work remained fragmented and open to interpretation. What historical conditions now demanded was a new type of collective avant-garde with a coherent revolutionary programme and organisational methods derived from the revolutionary underground. He specifically criticised Surrealism for its dogmatic belief in the "infinite wealth of the unconscious imagination". Rather than the "chief power of life", Debord stated, we now know that the:

unconscious imagination is poor, that automatic writing is monotonous, and that the whole genre of the "unusual", which the changeless surrealist trend ostentatiously parades, is extremely unsurprising. Strict fidelity to this style of imagination ends by reducing itself to the very opposite of the modern conditions of the imaginary, that is, to traditional occultism.[4]

Debord, Guy, "Report on the Construction of Situations", 2002, p. 33.

With its predecessors thus criticised the SI was ready to take its place as the culmination of the history of the avant-garde.

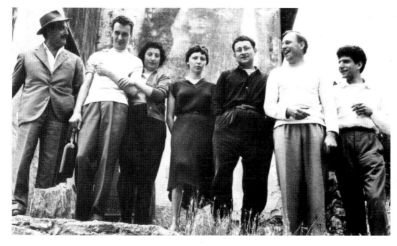

Cosio d'Arroscia, Italy, 1957.
From left to right: Pinot-Gallizio, Piero Simondo, Elena Verrone, Michèle Bernstein, Guy Debord, Asger Jorn, Walter Olmo.

The founding conference took place on the 27 and 28 July 1957 in the tiny rural community of Cosio d'Arroscia, in the Italian province of Imperia in the Ligurian Alps. The village was the birthplace of the artist Piero Simondo and the visiting delegates stayed in his large family home. Representing the LI were Bernstein and Debord and representing the IMIB were Pinot-Gallizio, Jorn, Olmo, Simondo and Verrone. The sole representative of the LPC was Rumney (accompanied by his partner Pegeen Guggenheim, the art collector Peggy Guggenheim's daughter). After two days discussing Debord's "Report" the proposed unification of the groups went to a vote on the evening of 28 July. According to a note in *Potlatch* (no. 29) the voting went five to one in favour, with two abstentions. The result meant the SI was now officially in business.

Although who voted against the merger or who abstained was never made public, Debord quickly set about manufacturing the expulsion of Olmo, Simondo and Verrone. This development began in October 1957 with Debord's circulation of an internal document, *"Remarques sur le concept d'art expérimental"* ("Remarks on the Concept of Experimental Art"), a direct and critical response to Olmo's *"Per un concetto di sperimentazione musicale"*

See Gérard Berréby ed., *Textes et documents situationnistes, 1957-1960*, Paris: Éditions Allia, 2004, pp. 26-33.

("Toward a Concept of Musical Experimentation").[5] The process ended in January 1958, when the SI convened for its first Paris conference. The meeting was attended by Bernstein, Debord, Jorn, Pinot-Gallizio, and Abdelhafid Khatib, representative of the Algerian section (and according to

Hussey, *The Game of War*, 2001, p. 138.

rumour the chief supplier of high quality kif to the group).[6] Not present to defend themselves, Olmo, Simondo and Verrone were officially excluded.

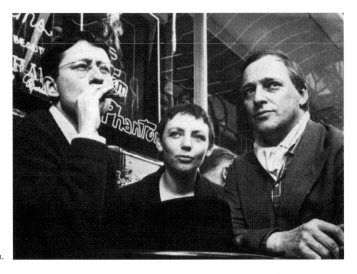

Guy Debord, Michèle
Bernstein and Asger Jorn.

## The Launch of
### *Internationale situationniste*

Olmo's text on musical experimentation had been written for the first issue of the SI's new journal, *Internationale situationniste* (*IS*). Another work intended for that first issue and also failing to appear was Rumney's psychogeographic survey of Venice. When it arrived two months late for

It was later reproduced in Iwona Blazwick ed., *An endless adventure.... an endless passion... an endless banquet: A Situationist scrapbook*, London: ICA and Verso, 1989, pp. 45-49.

inclusion Rumney was summarily excommunicated.[7] In its place Debord published a couple of mug-shots of Rumney and a short text "Venice Has Conquered Ralph Rumney": "Rumney has disappeared, and his father has yet to start looking for him. Thus it is that the Venetian jungle has shown

itself to be the stronger, closing over a young man, full of life and promise, who is now lost to us, a mere memory among so many others."[8] Rumney's very reasonable excuse for being late related to complications surrounding the birth of his son with Pegeen. He did not take exclusion easily and later admitted it left him very demoralised, although he also realised his own responsibilities: "I recall having said in Cosio that any lack of the fanaticism necessary for our advancement must be punished by expulsion."[9]

Rumney, *The Consul*, 2002, p. 54.

Rumney, *The Consul*, 2002, p. 54. In 1967 Pegeen died of an overdose of sleeping tablets and whiskey, and her mother tried to have Rumney arrested for "murder and failing to assist a person in danger". Partly to escape her attention Rumney sought refuge at Félix Guattari's clinic at La Borde. Only after he was assured there were no grounds for his prosecution did he leave Paris. In 1970 he returned and worked as a broadcaster on the radio station ORTF. While in Paris at a gallery party he bumped into Michèle Bernstein. They resumed their friendship and married a couple of years later. Rumney died of cancer after a long illness in March 2002.

Conference in Anvers, 1962.

The first issue of *IS* appeared in June 1958, with Debord named as editor and the editorial committee consisting of Dahou, Pinot-Gallizio, and Maurice Wyckaert. Bound in stunning gold-coloured card wrappers, only about 200 copies were printed of this first edition.[10] Through the 11 years of its existence it stayed remarkably consistent in style, with only the colour of its metallic covers changing for each issue. The key strategic significance of journals within the history of the avant-garde, such as *Dada* and *La Révolution surréaliste*, was a lesson well learnt by the SI. As Debord later wrote, in addition to bankrupting its two printers, the journal "dominated this period, and it attained its goal. It was very important for passing on our theses in this epoch".[11] The first issue included an attack on Surrealism, an article on rebellious youth in various countries, an outline of the theory of the "constructed situation", Jorn's theories on automation, Bernstein on the uselessness of leniency and Debord on the Cultural Revolution. Moments of levity were provided by photographs of young women in bikinis and the journal's self-advertisement:

*Internationale situationniste 1958-1969*, Paris: Éditions Champ Libre, 1975. Complete facsimile edition of the journal, nos. 1-12 (June 1958-Sept. 1969).

Guy Debord and Gianfranco Sanguinetti, *The Veritable Split in the International*, London: Chronos, 1990, p. 90.

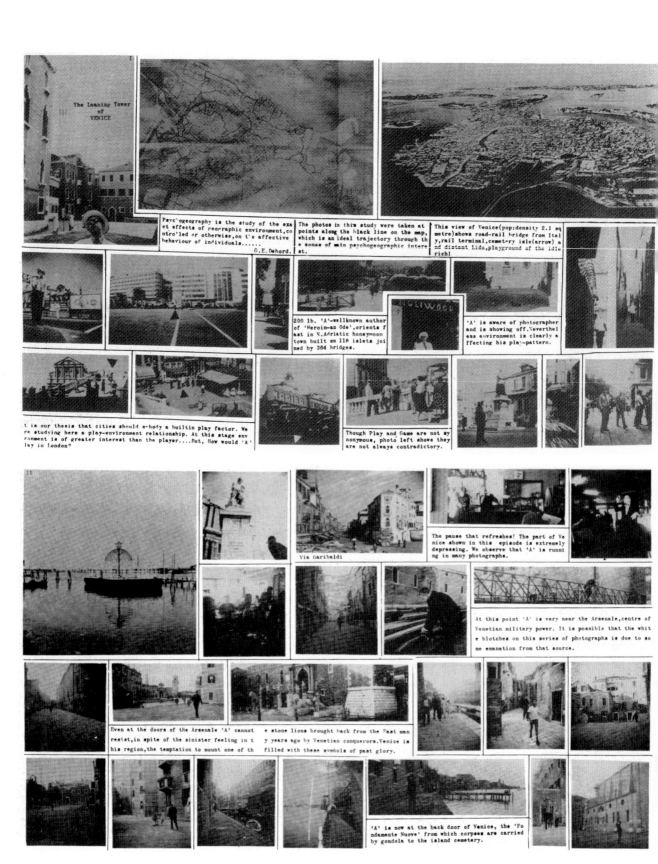

Ralph Rumney, Psychogeographic map of Venice, 1957.

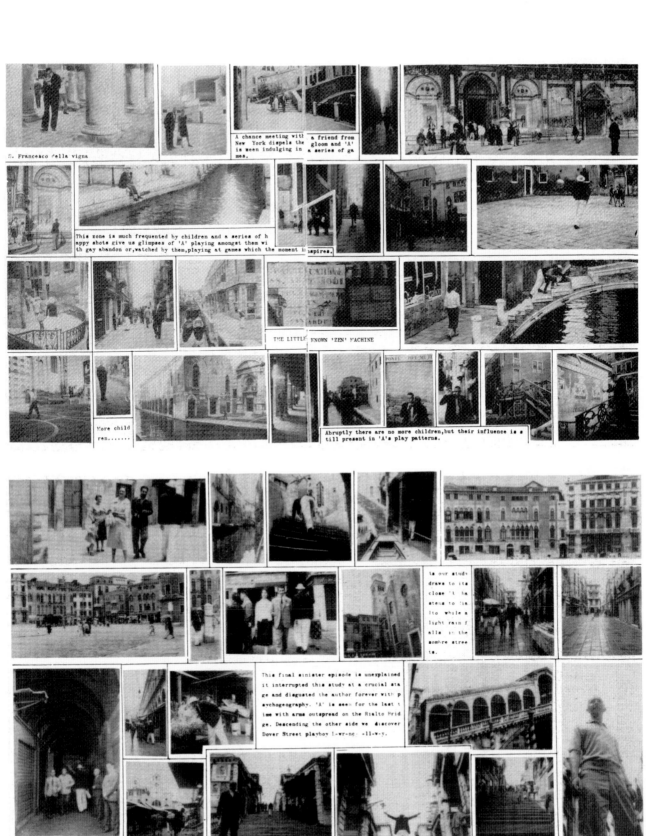

S. Francesco della vigna

A chance meeting with a friend from New York dispels the gloom and 'A' is seen indulging in a series of games.

This zone is much frequented by children and a series of happy shots give us glimpses of 'A' playing amongst them with gay abandon or,watched by them,playing at games which the moment inspires.

THE LITTLE KNOWN 'ZEN' MACHINE

More children.......

Abruptly there are no more children,but their influence is still present in 'A's play patterns.

As our study draws to its close 'A' listens to Rialto while a light rain falls in the sombre streets.

This final sinister episode is unexplained it interrupted this study at a crucial stage and disgusted the author forever with psychogeography. 'A' is seen for the last time with arms outspread on the Rialto Bridge. Descending the other side we discover Dover Street playboy I-wr-nc- -ll-v-y.

YOUNG GUYS, YOUNG GIRLS

Talent wanted for getting out of this and playing

No special qualifications

Whether you're beautiful or you're bright

History could be on your side

WITH THE SITUATIONISTS

No telephone. Write or present yourself:

32, rue de la Montagne-Geneviève, Paris 5°.

The journal also included an article by an absent friend, "Formulary for a New Urbanism" by Ivan Chtcheglov (published under the pseudonym 'Gilles Ivain'). Chtcheglov, born of Russian refugee parents, had written the text in 1953 whilst a member of the LI (before his exclusion in 1954 for "mythomania, interpretative delirium, lack of revolutionary consciousness").[12] As reported in *Potlatch*, no. 2, 29 June 1954. By the time of the article's publication in 1958 he had been committed to a mental hospital and undergone debilitating electro-shock and insulin treatment. In the text Chtcheglov complained, "We are bored in the city" and demanded, "The hacienda must be built". New conceptions of space were to be sought "in the magical locales of fairy-tales and surrealist writings, castles, endless walls, little forgotten bars, mammoth caverns, casino mirrors". Architecture was to become "a means to experimenting with a thousand ways of modifying life" with the dreamscapes of Giorgio de Chirico as its most remarkable precursor.[13]

Chtcheglov, Ivan "Formulary for a New Urbanism", in Knabb, *SI Anthology*, 1981, pp. 1-4. Other acknowledged influences on the LI and SI's conception of an architectural utopia were the labyrinthine drawings of the eighteenth century artist Giovanni Piranesi, the fantastic castle at Neuschwanstein built by 'Mad' King Ludwig II of Bavaria, and the Palais Idéal by 'Le Facteur' (The Postman) Ferdinand Cheval built between 1879-1905 and fastidiously explored and documented by Debord and the Lettristes in the 1950s, just as it had been celebrated before them by Breton and the Surrealists.

Illustration from *IS*, no. 8, 1963.

Top and bottom:
Illustration
from *IS*, no. 7, 1962.

j'aime ma caméra

parce que

j'aime

vivre

j'enregistre les
meilleurs moments
de l'existence

je les ressuscite
à ma volonté
dans tout leur éclat

LA DOMINATION DU SPECTACLE SUR LA VIE

Illustration from *IS*,
no. 11, 1967.

In 1982 it also inspired Anthony H Wilson to name his new nightclub in Manchester, The Haçienda. Also worthy of mention in relation to the SI is Wilson's Factory Records group the Durutti Column, whose first album came in a sandpaper sleeve in homage to Debord's sandpaper-bound *Mémoires*.

The inclusion of Chtcheglov's text acknowledged its key role in the development of unitary urbanism and in the years to come it would also influence Constant and his plans for *New Babylon*.[14]

The journal also included a useful list of key terms and their definition. The "constructed situation" was defined as a "moment of life, concretely and deliberately constructed by the collective organisation of unitary environment and the free play of events". Meanwhile a "Situationist" was simply someone who "engages in the construction of situations". Two terms closely related according to the SI were "culture" and "decomposition". The first could be summed up as: "The reflection and prefiguration at any given historical moment, of the possible organisation of daily life; the complex of mores, aesthetic, and feelings by which a collective reacts to a life which is objectively given to it by

its economy." "Decomposition" was a process by which these cultural forms had "destroyed themselves, under the effects of the appearance of superior means of dominating nature, permitting and requiring superior cultural constructions". The definition goes on to distinguish between an "active phase" of decomposition that ended around 1930 and a phase of "repetition", which has been the norm since that date. "The delay in passing from decomposition to new constructions", it concluded, "is tied to the delay in the revolutionary liquidation of capitalism". The text also made it quite clear what the SI thought of "situationism" and those who might want to use it: "A word totally devoid of meaning... There is no situationism, which would mean a theory of interpretation of existing facts. The notion of situationism was obviously conceived by anti-situationists."[15]

Knabb, *SI Anthology*,1981, pp. 45-6.

Early attempts to give concrete form to these concepts, unitary urbanism and psychogeography in particular, resulted in Debord's "useless" maps–*Guide psychogéographique de Paris: discours sur les passions de l'amour* (*Psychogeographic Guide to Paris: discourse on the passions of love*)[16], 1956, and *The Naked City: illustration de l'hypothèse des plaques tournantes en psychogéographique* (*The Naked City: Illustration of the hypothesis of geographic turntables*)[17], 1957–both of which split maps of Paris into free floating sectors connected by red arrows indicating "psychogeographic" flows.

A screen-printed map made in collaboration with Asger Jorn using cut out fragments from the perspectively rendered *Plan de Paris à vol d'oiseau*, 1956, drawn by G Peltier. Both maps are discussed in depth in Sadler, 1998, pp. 82-91.

The cut up map is the *Guide Taride de Paris*, 1951.

Debord's maps challenged traditional ideas of mapping relating to scale, location and fixity and drew on the work of urban social geographer Paul-Henri Chombart de Lauwe, and his concept of the city as a conglomeration of distinct quarters, each with its own special function and class divisions.[18] They also focused on Debord's favourite areas of Paris and as such could be described as Situationist tourist guides. Debord named the second map *Naked City* in honour of Jules Dassin's 1948 detective film and because he liked the idea of himself as a detective stalking the city looking for clues to its significance and to its seductive power. The map carried a text that described the schematic directional arrows as representing "the spontaneous turns of direction taken by a subject moving through these surroundings in disregard of the useful connections that ordinarily govern his conduct".[19] In these maps deterministic orientation was replaced by the "free" psychogeographic flow of a completely new way of life and travel.

Chombart de Lauwe, Paul-Henri, *Paris et l'agglomération parisienne*, Paris: Presses Universitaires de France, 1952.

Debord, Guy, *The Naked City*, 1958, verso. Translation from Tom McDonough, 'Situationist Space', in McDonough, *Guy Debord*, 2002, p. 243.

# Jorn's Modifications and Disfigurations

Asger Jorn.

During the first few years of the SI's existence Jorn's eminence as an internationally renowned artist continued to grow. His works steadily increased in value and he held countless exhibitions in both commercial galleries and museums throughout Europe. But, despite these many pressures on his time he never neglected his duties and commitment towards the SI. In May 1957 he collaborated with Debord (described as "counsellor for *détournement*") on the book *Fin de Copenhague* (*End of Copenhagen*). The book consisted of found images and text (collected, according to legend, during a single visit to a news-stand) overlain with a network of Jorn's painted drips and dribbles. With the help of Jorn's friend, the lithographer VO Permild, the book was completed within

Jorn, Asger and Guy Debord, *Fin de Copenhague*, Copenhagen: Permild & Rosengreen, 1957. Facsimile edition published in 1985 by Éditions Allia.

a day and 200 copies printed.[20] Debord and Jorn intended the book to be a satirical attack on consumer and technological society, using elements from commercial culture to critique itself. You can sense their disdain when they

Left and right:
Asger Jorn and
Guy Debord, *Fin de
Copenhague*, 1959.

**Lorsqu'on lui demande s'il aimer**

WHEN ASKED IF HE WOULD LIKE

**un Dubonnet avant le dîner,**

A DUBONNET BEFORE DINNER,

**mon oncle répond qu'il aimerai**

MY UNCLE REPLIES THAT HE WOULD LIK

**un Dubonnet avant n'importe qu**

A DUBONNET BEFORE ANYTHING!

vær i go' form

AIR

IN

DUST

COSMOS SENNEP

…ne tendency of each generation to react against its predecessor, of that future has arrived. But this is more than changes in fashion. It is extraordinary that the ideas of a Schönberg and Stravinsky, who, what-ever may be thought of their, a matter of ' the inability alien from those to obtain now that future to a gener- extent be the gener- for " futurism in music should seem to illustrated by his slight e.

musician who in his lifetime did battle a prophet to foresee the future, as

the present century. ever may be thought of their

Vespa

FANS FOR

something like horror in the best circles.

AIRSCREW

A NOBLE FAILURE

OUTMODED PHILOSOPHY

His ne… w aesthetic was to pre music wa… s no longer to be split u ing to pu… rpose (i.e., for theatre or form (i.e… , song, fugue, sonata),

**S**OMETHING is wrong, but w pulling the wool over whose eye…

proved to be the seminal forces

Busoni himself seemed always to have been recognized as not only a great musician but as a musical thinker who might have resolved the crisis in our music …nich has persisted now for half a century. But he also seems to have ultimately failed all that he did. His failure is noble

quoted a text promising that, thanks to electronics, automation and nuclear energy "we are entering the new Industrial Revolution which will supply our every need, easily, quickly, cheaply, abundantly". Just over a year later Debord and Jorn collaborated on *Mémoires*, in style a very similar book, but this time famously bound within raw sandpaper wrappers and with a different subject matter, the early history of the LI.[21] Once again the book consisted of Jorn's lines, drips and blotches of paint with short passages of text borrowed by Debord from sources as diverse as travel brochures, novels, political tracts, and newspapers, and appropriated imagery including photographs, cartoons, maps, and old book illustrations.

Jorn, Asger and Guy Debord, *Mémoires*, Paris: Internationale situationniste, 1959. See also Boris Donné, *(Pour Mémoires)*, Paris: Éditions Allia, 2004 and Greil Marcus, "Guy Debord's *Mémoires*: A Situationist Primer", in Sussman, *On the Passage*, 1989, 124-131.

Left and right:
Asger Jorn and Guy Debord, *Fin de Copenhague*, 1959.

D'émouvants accidents

A DEMI ENFOUIS SUR LES COTEAUX DE L'ILE DE PAQUES

Left and right: Asger Jorn and Guy Debord, *Mèmoires*, 1957.

On balaieraít le vieux monde

on n'entre pas seul dans l'histoire, comme le chevalier entre seul en lice

la tension de l'esprit en incessante méditation tourments d'un cœur inquiet et angoissé

le siège périlleux

les sociétés secrètes et leurs agissements

Yo-ho-ho ! et une bouteille de rhum !

— Allons, Cochon-Rôti, donne-nous un refrain, lança quelqu'un.
— Celui de jadis, cria un autre.
— Bien, camarades, répondit Long John, qui se tenait auprès d'eux, reposant sur sa béquille.
Et aussitôt il attaqua l'air et les paroles que je connaissais trop :

Nous étions quinze sur le coffre du mort...

Gilles

— Les gentilshommes de fortune se fient géné-ralement peu les uns aux autres, et ils ont raison

le double jeu de la comédie et du drame, du drame et du divertisse-ment, tout cela

Rien ne s'arrête pour nous. C'est l'éte... nous est naturel, et toutefois le plus contraire à inclination; nous brûlons de désir de trouver

Jorn's most lasting contribution to the artistic output of the SI was his two sets of *détourned* paintings, described by one commentator as

Gilman, Clare, "Asger Jorn's Avant-Garde Archives" in McDonough, *Guy Debord*, 2002, p. 196.

"the quintessential manifestation of situationist art practice".[22] Jorn bought the original paintings by either anonymous or amateur artists in the Paris flea markets. He then added his own particular brand of creative vandalism. The first in this series, *Modifications (peintures détournées)* (*Modifications: Détourned Paintings*), were shown in May 1959 at the Galerie Rive Gauche in Paris. One of the paintings, *Paris by Night*, 1959, showed a man leaning on railings looking down on the houses below. All around him circle Jorn's painted figures, like mischievous spirits trying to break the man's reverie. Jorn accompanied the paintings with two texts rationalising this new form of sacrificial collaboration. The first was addressed to the general public: "Be modern, collectors, museums! If you've got old pictures, don't despair. Keep your memories but modify them and bring them up to date. Why reject the old if it can be modernised with a few strokes of the brush?" Jorn addressed the second text to 'connoisseurs' and ended it with this explanation:

In this exhibition I erect a monument in honour of bad painting. Personally, I like it better than good painting. But above all, this monument is indispensable, both for me and for everyone else. It is painting sacrificed. This sort of offering can be done gently the way doctors do it when they kill their patients with new medicines that they want to try out. It can also be done in barbaric fashion, in public and with pomp. This is what I like. I solemnly tip my hat and let the blood of my victims flow while

Jorn, Asger, "Détourned Painting", in Sussman, *On the Passage*, 1989, pp. 140-142.

intoning Baudelaire's hymn to beauty.[23]

Jorn had his second exhibition of the modifications–now entitled *Nouvelles défigurations* (*New Disfigurations*)–in June 1962 at the same Parisian gallery. This series included landscapes, battle scenes and portraits. *L'avant-garde se rend pas* (*The Avant-Garde Doesn't Give Up*)–depicted a young girl in a pale

Asger Jorn, *Dolche Vita*, 1962. Courtesy: Silkeborg Museum.

dress with Jorn's mischievous addition of a moustache and goatee. The reference to Marcel Duchamp's *L.H.O.O.Q.* (in which he drew a moustache on a photographic reproduction of the *Mona Lisa*) was obvious. What was extraordinary, however, was the confrontational stare of the little girl. The painting was meant as a warning for anybody who thought the avant-garde might be dead. With this work and the other *détourned* paintings Jorn created something of enduring cultural value from the kitschiest of source material. By the time of his second exhibition Jorn had already resigned from the SI (in April 1961), but he continued to keep in touch with Debord and would often present him with paintings and cash to help fund the organisation and the journal.[24] Jorn eventually died of lung cancer on 1 May 1973. In a commemorative essay Debord wrote that Jorn was more of a Situationist than anybody else: "the permanent heretic of a movement that cannot tolerate any orthodoxy. Nobody contributed as much as Jorn did to the origins of this adventure: he found people throughout Europe; he came up with so many ideas."[25]

Anderson, Troels, "Asger Jorn and the Situationist International", in Sussman, *On the Passage*, 1989, p. 66. Jorn also published Debord's book *Contre le cinema* in 1964 and financed the making of two films, *Sur le passage de quelques personnes à travers une assez courte unite de temps*, 1959 and *Critique de la séparation*, 1961, both under the auspices of his new organisation, the Scandinavian Institute for Comparative Vandalism (see Chapter 4).

Debord, Guy, "On Wild Architecture" in Sussman, *On the Passage*, 1989, p. 174. First published in *Le Jardin d'Albisola*, Turin: Edizioni d'arte Fratelli Pozzo, 1974.

## Pinot-Gallizio's Industrial Painting

Another artist and founder member of the SI experiencing art world success was Pinot-Gallizio. His first exhibition of what he termed his "industrial paintings" took place at the Notizie Gallery in Turin, Italy in May 1958. These consisted of rolls of canvas painted in collaboration with his son Giors Melanotte using various spray guns and homemade 'painting machines'. Pinot-Gallizio made good use of his past experience as a chemist to experiment with oil paints mixed with special resins and solvents, and natural material such as iron filings, sand and coal. His intention was to sell the rolls of canvas by

the metre. Some sections of these rolls he hung over a 'therminphone', an instrument developed by a Professor Cocito that produced sounds in reaction to the proximity of viewers. In July the show travelled to the Montenapoleone Gallery in Milan, this time accompanied by Bernstein's sales pitch, "Elogio di Pinot Gallizio"("In Praise of Pinot-Gallizio"):

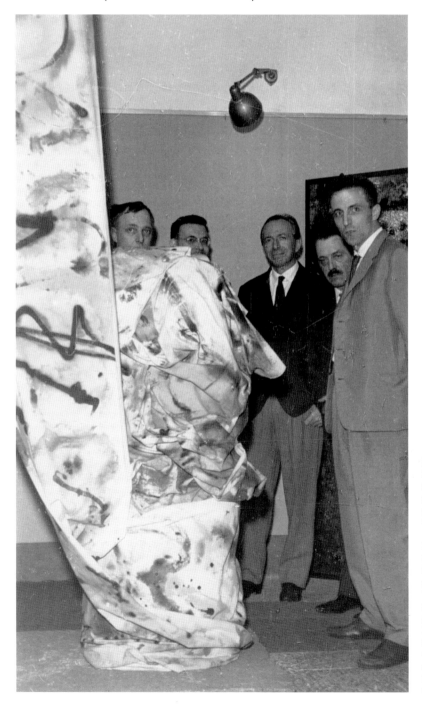

Left:
Pinot-Gallizio in front of *La triste et deplorable histoire du roi Tete-de-Pipe*, 1960.

Right:
First exhibition of industrial painting at the Galleria Notizie, Turin, 1958. From right to left: the gallerist Luciano Pistoi, Pinot-Gallizio, the sculptor Franco Garelli, a friend, and Asger Jorn. Photo: Archivio Gallizio, Turin.

Its cost price beats all competition. Its sale price too: Gallizio is honest. His production is unlimited. No more speculators on canvases: if you have money to invest, be content to buy shares in the Suez Canal. His sales take place preferably outdoors. Also in small shops and large department stores: Gallizio dislikes galleries. It is hard to grasp all at once the myriad advantages of this astonishing invention. At random: no more problems of size–the canvas is cut before the eyes of the satisfied customer; no more bad periods–because of its shrewd mixture of chance and mechanics, the inspiration for industrial painting never defaults; no more metaphysical themes –industrial painting won't sustain them; no more doubtful reproductions of eternal masterpieces; no more gala openings.[26]

Bernstein, Michèle, "In Praise of Pinot-Gallizio", in McDonough, *Guy Debord*, 2002, pp. 69-71. First published in *Pinot-Gallizio*, Paris: Bibliothèque d'Alexandrie, 1960.

In May 1959 Pinot-Gallizio covered the walls, floor and ceiling of the René Drouin Gallery in Paris with 145 meters of industrial painting to create a "cavern of anti-matter". To make it a total environment he also sprayed the air with perfume and had female models circulate around the space clothed in dresses made up from the rolls of canvas. Later that year he published the *"Manifesto della pittura industriale"* ("Manifesto of Industrial Painting"). Influenced by the Futurists and the philosopher Gaston Bachelard, the text called for artists to become creators of whole environments and completely new ways of living, in which the machine would be mastered and utilised "for the

Left:
Models wearing rolls
of industrial painting
at the first exhibition
at the Galleria Notizie,
Turin, 1958. Photo:
Archivio Gallizio, Turin.

Right:
Pinot-Gallizio, the
cavern of anti-matter,
René Drouin Gallery,
Paris, 1959. Photo:
Archivio Gallizio, Turin.

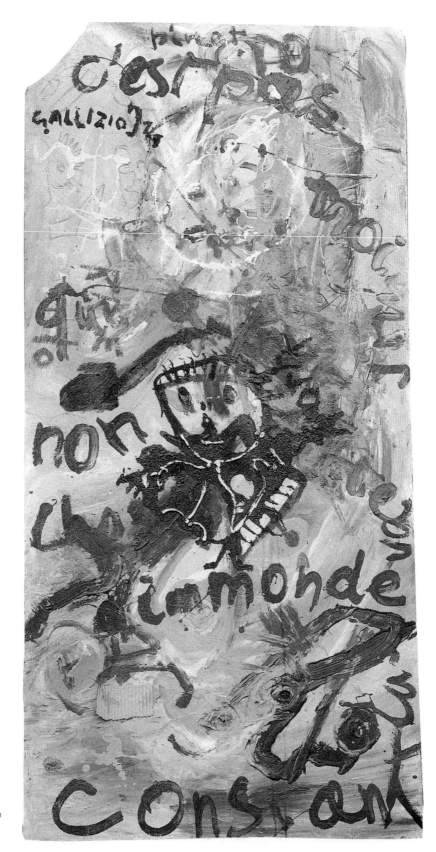

Left:
Pinot-Gallizio,
Asger Jorn, Constant,
*Untitled*, collective
work, 1957. Collection
Liliana Dematteis,
Turin.

single, useless, anti-economic and artistic gesture through which a
new society–anti-economical, poetic, magical and artistic–will come
into existence."[27]

Bandini, Mirella "Pinot-Gallizio: il 'Primo Laboratorio di Esperienze Immaginiste del Movimento per una Bauhaus Immaginist' (Alba 1955-57) e il 'Laboratorio Sperimentale d'Alba dell'Internazionale Situazionista' (1957-60)", *Data* (Italy), vol. 3, no. 9, Autumn 1973, pp. 16-29, 82-5, 94-5.

Debord's friendship with Pinot-Gallizio and Melanotte ended on the 31 May 1960, when he excluded them from the SI on the grounds of their increasing ties with the commercial art world. With the departure of Pinot-Gallizio another of the founder members had been dispensed with and Debord was left with even more influence on the movement. Unperturbed Pinot-Gallizio continued his work at Alba and many artists and critics visited him there, enjoying the hospitality and atmosphere of industrious creativity. On hearing the news of Pinot-Gallizio's sudden death in February 1964 Debord

Editorial, "Les mois les plus longs", *IS*, no. 9, August 1964, p. 36.

wrote that the origins of the SI "owe him a lot".[28]

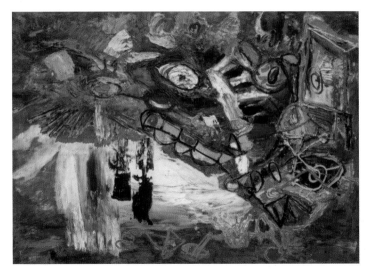

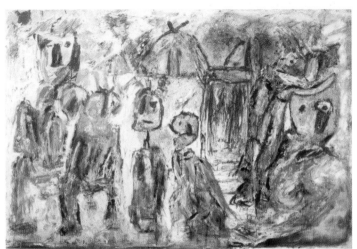

Top:
Pinot-Gallizio,
*Le macchine del vento*,
oil and mixed
technique on canvas,
1959. Courtesy:
Galleria Martano, Turin.

Bottom:
Pinot Gallizio, *I guitti*,
oil and mixed
technique on canvas,
1956. Courtesy:
Galleria Martano, Turin.

# Constant's *New Babylon*

Constant

The artist Constant Nieuwenhuys was born in Amsterdam in 1920. Before joining the SI he had been a member of the Dutch Experimental Group (formed in July 1948 with Karel Appel, Guillaume Corneille, and Jan Nieuwenhuys) and then Cobra. After Cobra's self-destruction Constant gave up painting and moved to London to begin an investigation into urbanism and city planning. Like many associated with the SI he was deeply influenced by Johan Huizinga's *Homo Ludens*, 1938, a book highlighting the importance of play in the development of mankind, elevating *homo ludens* to the same level of importance as *homo faber* (man as maker) and *homo sapiens* (man as thinker).[29]

Huizinga, Johan, *Homo Ludens: A Study of the Play Element in Culture*, New York: Harper and Row, 1970. First published in Dutch in 1938, translated into English in 1949 and into French in 1951. See Libero Andreotti, "Architecture and Play" in McDonough, 2002, pp. 213-240.

After attending the First World Congress of Free Artists in 1956 Constant stayed on at Alba to work on a series of models of environments and buildings designed to be infinitely re-arrangeable. Through Pinot-Gallizio he had made contact with local gypsies, and proposed to build them a camp. The models and blueprints for this camp eventually developed into a project that would occupy him until 1974. The name for this project, *New Babylon*, came out of a brainstorming session with Debord in 1959. Up to that point Constant had been describing the prospective city as *"Dériville"*, but Babylon, as the home of such architectural marvels as the famed Tower of Babel and as a by-word for wickedness, summed up both Constant's architectural ambition and the libertarian nature of the new society he hoped to be accommodated there.[30]

Lambert, Jean-Clarence ed., *New Babylon/Constant*, Paris: Cercle d'Art, 1997, p. 25. The appellation of 'New' apparently came about because of Debord's love of American comic book culture. See the Constant interview in Hans Ulrich Obrist, *Interviews: Volume 1*, Milan: Charta, 2003, p. 172.

Constant contrasted today's utilitarianism to a future ludic society where the "dynamic labyrinth" (an ever-shifting maze) would represent the paradigm of both architectural and social utopia, perhaps best summed up in the title of a 1962 drawing, *Labyratorium*, architecture as half labyrinth and half laboratory. The citizens of *New Babylon* would roam freely within this radically decentred environment. No longer would architecture be the concrete manifestation of a controlling social order, the city would consist of a series of zones to move through rather than distinct places for permanent occupation. These ideas set the project in direct opposition to the rationalist planning of the Congres Internationaux d'Architecture Moderne (CIAM) and

the signatories of its Athens Charter of 1943 which argued for the functional segregation of the city. CIAM and its ideas were disparaged by the SI as advocating the "concentrationary organisation of life".[31] The main figure of hate was Le Corbusier, who the LI had already described as a builder of "vertical ghettoes" and, the most sickening crime of all, the architect of churches.[32]

Anon, "Critique of Urbanism", in Andreotti and Costa, *Theory of the Dérive*, 1996, p. 112. First published in *IS*, no. 6, August 1961.

Anon, "Skyscraper By The Roots", in Andreotti and Costa, *Theory of the Dérive*, 1996, p. 44. First published in *Potlatch*, no. 5, 20 July 1954.

Top and Bottom: Constant, Illustrations for *International Situationniste*, no.3, 1959.

The difficulty for Constant was to create an architecture for a society yet to be created. In *New Babylon*'s post-revolutionary social order religion would not exist and the factories and production lines would all be automated and placed out of sight underground. "For the first time in history", he wrote optimistically, "mankind will be able to establish an affluent society in which nobody will have to waste his forces, and in which everybody will be able to use his entire energy for the development of his creative

Constant, "New Babylon/An Urbanism of the Future", quoted in Sadler, *The Situationist City*, 1998, p. 136.

capacities".[33] *New Babylon* would be elevated on stilts and columns, leaving the ground below free for the circulation of traffic. The combination of free time and free movement would create new social relationships between the *New Babylonians*, while transforming the very basis of time and space. Distinctions between work and leisure and public and private space would disappear. *New Babylon*'s massive and complex structure represented the opposite of a return to nature, this was the "overcoming of nature", with environmental conditions, such as climate, light and sound, under the control of the inhabitants, or more specifically, a new type of professional: "The ambiences will be regularly and consciously changed, with the aid of every technical means, by teams of specialised creators who, hence, will be

Constant, "Another City for Another Life", in Andreotti and Costa, *Theory of the Dérive*, 1996, p. 97. First published in *IS*, no. 3, December 1959.

professional situationists."[34]

Constant's first significant contribution to the development of Situationist theory came in December 1958 when he co-wrote with Debord the 11-point "Amsterdam Declaration" on unitary urbanism. Together they

Constant, Illustrations from *International Situationniste*, no. 3, 1959.

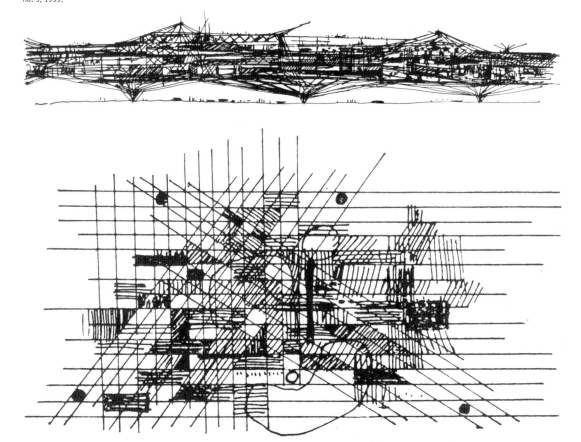

stated: "A constructed situation is a means for unitary urbanism. Just as unitary urbanism is the indispensable basis for the construction of situations, in both play and seriousness, in a freer society."[35] The declaration drew on the LI's long battle against what they saw as a functionalist and dehumanising urbanism. In its place they posited an architecture of play and transparency of human relations. In Amsterdam in February 1959 Constant set up the Bureau of Unitary Urbanism with his friend Armando, and the architects Har Oudejans and A Alberts. He also regularly contributed to the SI journal up to the fourth issue and his resignation in June 1960.

Constant's departure resulted from his falling out with Debord over his association with both the Van de Loo Gallery and Oudejans and Alberts (the latter pair having been excluded from the SI for accepting a commission to build

Constant and Guy Debord, "The Amsterdam Declaration", in Andreotti and Costa, *Theory of the Dérive*, 1996, p. 80. First published in *IS*, no. 2, December 1958.

Constant, Monument de la reconstruction, Rotterdam, 1955.

a church). His exit, however, had nothing to do with Debord's wish to exclude artists from the group. As Constant explained: "I quit it because there were actually too many painters in this Situationist movement. ... I always opposed it. How can you work on urbanism when you are surrounded only by painters?"[36]

Constant in Benjamin Buchloh, "A Conversation with Constant", in Catherine De Zegher and Mark Wigley eds., *The Activist Drawing: Retracing Situationist Architectures from Constant's New Babylon to Beyond*, New York: The Drawing Center and MIT Press, 2001, p. 23.

According to Constant, Debord tried to remain in contact but he refused all efforts at reconciliation.[37] His resignation from the SI, however, did not stop him continuing to work on *New Babylon*, until June 1974 when

Constant later became an associate of the anarchic Provo movement in Amsterdam which adopted his architectural projects wholeheartedly. *New Babylon* would also find strong echoes in the *Plug-in City* of Archigram and the *Endless Cities* of Superstudio.

he exhibited all his models, drawings and paintings in a major retrospective at the Haags Gemeentemuseum. By this time he had become disillusioned with the project. In Mark Wigley's words Constant had become certain that "if people are granted the freedom that *New Babylon* offers, they will violently abuse each other".[38] His doubts led to a critique of his own project

Wigley, Mark, "Chronology" in De Zegher and Wigley, *The Activist Drawing*, 2001, p. 148. For a full account of Constant's work see: Mark Wigley, *Constant's New Babylon: The Hyper-Architecture of Desire*, Rotterdam: 010 Publishers, 1998.

and the production of a new series of *New Babylon* images, this time as a dystopian nightmare.

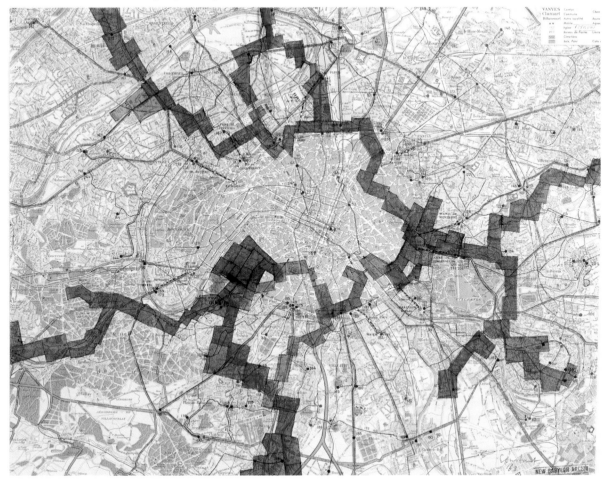

Constant, *New Babylon Paris*, 1963. Courtesy: Haags Gemeentemuseum.

## Debord's Films

Debord's work in cinema began in 1952 with the film *Hurlements en faveur de Sade* (*Howlings in the Favour of Sade*). Despite its minimal use of visual imagery the film touched on many themes that would continue to provide the subject matter for Debord's subsequent films, specifically the history of his immediate environment and the friends that lived there. This became the main topic of his next film, made seven years later in 1959, *Sur le passage de quelques personnes à travers une assez courte unité de temps* (*On the Passage of a Few Persons Through a Rather Brief Unity of Time*). Shot in black and white, on 35mm film stock, the film lasted just 20 minutes. Jorn financed the project through his own film production company Dansk-Fransk Experimentalfilmkompagni. The film's subject, 'the few persons' of the title, referred to the Saint-Germain-des-Prés milieu of the tribe. In a letter to fellow SI member André Frankin, dated 26 January 1960, Debord described it as an "anti-art-film". Although its first section appeared to resemble a conventional documentary, he explained, it quickly unravelled and an increasing discrepancy emerges between the images on the screen and the commentary on the soundtrack. In this way it becomes "more clear as its creator takes sides against it". This conflict thus provided the film with "an ultimately realistic description of a way of life deprived of coherence and significance".[39]

Debord, *Complete Cinematic Works*, 2003, p. 214.

The soundtrack included the voices of Jean Harnois, Claude Brabant and Debord. All were directed to speak, according to Debord, in a "somewhat apathetic and tired-sounding" voice. It became an established trait of Debord's films that the script possessed an equal or even a higher value than the images projected on to the screen. In *On the Passage* the text was predominantly Debord's but it also carried passages borrowed from philosophy, science-fiction and popular sociology. Likewise the film was mostly made up of clips from other films, although Debord encountered many problems with distributors refusing reproduction rights.[40] Debord obliquely commented on this form of censorship in the film's soundtrack:

One exception being the owners of the Monsavon soap advertisement, which featured the then unknown actress Anna Karina.

The ruling class's monopoly over the instruments we had to control in order to realise the collective art of our time had excluded us from a cultural production

officially devoted to illustrating and repeating the past. An art film on this generation can only be a film on its absence of real works.[41]

Debord, *Society of the Spectacle and Other Films*, 1992, p. 31.

The film did not just look back to the LI, it also looked forward to the programme of the Situationists, specifically the liberation of everyday life: "This entails the withering away of alienated forms of communication.

Debord, *Society of the Spectacle and Other Films*, 1992, p. 36.

The cinema too has to be destroyed."[42] Dialectically, Debord's plan to destroy cinema required the making of another film.

*Critique de la séparation* (*Critique of Separation*) came out in 1961 and was again produced by Jorn's Dansk-Fransk Experimentalfilmkompagni. This second short film of 20 minutes contained images borrowed from comic strips and newspapers, spliced together with shots of Debord on a café terrace talking to a young dark-haired woman, Catherine Rittener. Once again Debord employed three levels of signification: the images, the spoken commentary and the subtitles. He described the correspondence between these parts as "neither complementary nor indifferent", his intention at all times

Debord, *Complete Cinematic Works*, 2003, p. 213.

was to produce a 'critical' effect.[43] He was well aware of those rules of cinema that would produce a satisfactory result but he was starting from a point of dissatisfaction: "The function of the cinema, whether dramatic or documentary, is to present a false and isolated coherence as a substitute for a communication and activity that are absent. To demystify documentary cinema it is necessary

Debord, *Complete Cinematic Works*, 2003, p. 30.

to dissolve its 'subject matter'."[44]

The subject matter dissolved in *Critique of Separation* included the programme of the SI. At one point a subtitle appears below a still of a group of Situationists: "Passions have been interpreted enough. The point now is to discover new ones.... The new beauty will be a beauty of situations." The 'separation' of the title referred to the alienation produced by modern capitalist society, an alienation aided and abetted by its image producing industries: "Society broadcasts to itself its own image of its own history, a history reduced to a superficial and static pageant of its rulers–the persons who embody the apparent inevitability of whatever happens. The world of the rulers is the world of the spectacle." In contrast Debord's subjects attempted to escape this world and in his films there existed none of the

claims for coherence made on behalf of the spectacle: "This is a film that interrupts itself and does not come to an end. All conclusions remain to be drawn; everything has to be recalculated." The film ends with Debord declaring: "I have scarcely begun to make you understand that I don't intend to play the game."[45]

Debord, *Complete Cinematic Works*, 2003, pp. 33-9.

## The German and Scandinavian Sections

Jørgen Nash and Asger Jorn at Hotel Dania in Silkeborg, Denmark, 1962.

In September 1958 Jorn travelled to Munich and the Van de Loo Gallery to supervise the installation of an exhibition of his latest work. While staying in the city he met and befriended a group of younger artists and agreed to help fund their new magazine. The magazine, like the group, was called *Spur*, German for "trail" or "track". In November Jorn lent his signature to the group's first *Manifesto* since their obvious affection for kitsch was a trait he was keen to encourage:

Now it is the turn of the kitsch generation. WE DEMAND KITSCH, FILTH, ORIGINAL MUD, CHAOS. Art is the shitheap where kitsch is staking its claim. Kitsch is the daughter of art: the daughter is young and sweet-smelling, the mother an old woman who stinks. We want just one thing: to spread kitsch around.[46]

Quoted in Hussey, *The Game of War*, 2001, p. 135.

The main members of the Spur group were Lothar Fischer, Heimrad Prem, Helmut Sturm, and Hans Peter Zimmer, peripheral members included G Britt, Josef Senft, Erwin Eisch, Heinz Hofl, D Rempt, and Gretel Stadler.[47] The work of these painters and sculptors was semi-abstract and expressionist, but what really made the group distinctive was its political commitment to collective and collaborative working practices. By the time of the third SI conference in Munich from 17 to 20 April 1959, the Spur group formed a key part of the German section of the SI. Eisch, Prem, Stadler, Sturm, and

See Bachmayer, H M, "The 'Spur' Group: On Art, Fun and Politics", in Klaus Schrenk ed., *Upheavals, Manifestos, Manifestations: Conceptions in the Arts at the Beginning of the Sixties: Berlin, Düsseldorf, Munich*. Köln: DuMont, 1984.

Zimmer attended the conference and contributed to the celebratory closing

tract that announced its end: *Ein kultureller Putsch während Ihr schlaft!*

See Gruppe Spur, *Ein kultureller Putsch: Manifeste, Pamphlete und Provokationen der Gruppe SPUR*, Hamburg: Nautilus, 1991.

(*A Cultural Putsch While You Sleep!*).[48] The first issue of *Spur* appeared in

August 1960 edited by Sturm, Prem, Zimmer and Fischer. Another two

A facsimile edition of the collected *Spur* journals 1-7, August 1960-October 1961, was published as Helmut Sturm et al., *Die Zeitschrift SPUR*, München, 1962.

issues appeared during the year, followed by another three in 1961.[49] The

journal differed significantly from its French counterpart. The graphics

Top:
Spur, Situationister i konsten (Situationists in the arts), catalogue, Varberg, 1966.

Bottom:
"The Adventures of Superman the Situationist", Comic from *Spur* no. 2.

were often freehand and bold and the page layout adhered to a chaotic scrapbook aesthetic. *Spur* also continuously battled against censorship from the German authorities. At one point its editors were being prosecuted for pornography, blasphemy, incitement to riot, and ultimately, for contempt of court. Eventually, Uwe Lausen received a three week jail sentence and in May 1962, Dieter Kunzelmann, Prem, Sturm and Zimmer, received a five and a half month suspended sentence each (although these were subsequently reduced on appeal).

Jørgen Nash, 1966.

Throughout this period the SI, chiefly through the initiative of Jorn, also increased the size of its Scandinavian section with new members in the form of Jorn's younger brother, Jørgen Nash, and the artists Ansgar Elde, and JV Martin, with Hardy Strid, Steffan Larsson and Katja Lindell as close associates but not full members. Representatives of both the German and Scandinavian sections took part in the SI's fourth conference in London in September 1960. Matters of business included a debate over the extent to which the SI was a political movement. The German section proposed that the revolutionary potential of the proletariat was not something that could be relied upon and that "the SI should prepare to realise its programme on its own by mobilising the avant-garde artists, who are placed by the present society in intolerable conditions and can count only on themselves to take

Nash's poetry/collage book *Tyren I mit hjerte* (*The bull in my heart*), 1965.

over the weapons of conditioning". Debord was reported as responding with a "sharp critique" of this position and after a period of deliberation the German section agreed to retract its assertions and submit to the majority opinion

Anon, "The Fourth SI Conference in London", in Knabb, *SI Anthology*, 1981, p. 62.

of the SI.[50] This would not, however, be the end of this particular debate.

During the conference delegates also found time to compose a tract denouncing the arrest in the United States of the Scottish writer and Situationist fellow traveller Alexander Trocchi, for drug related offences. The conference ended on a particularly memorable note when the SI made a presentation at the Institute of Contemporary Arts. Wyckaert was delegated to read out in broken English the group's hastily composed "Declaration": "Situationism doesn't exist. There is no doctrine of this name. ... If you've understood that there is no such thing as "Situationism" you've not wasted

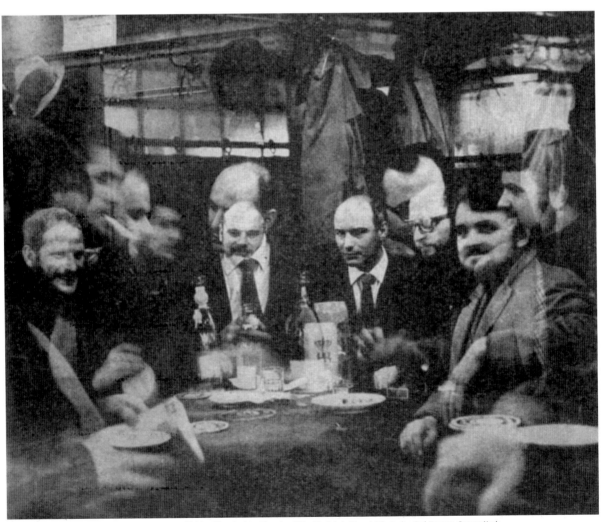

From the exhibition Situationister i konsten (Situationists in the arts) featuring Carl Magnus, Jørgen Nash, Heimrad Prem, Hardy Strid and Jens Jørgen Thorsen, Varberg, 1966.

your evening." He ended with a warning: "The Situationists, whose judges you perhaps imagine yourselves to be, will one day judge you. We are waiting for you at the turning." Upon finishing somebody in the audience foolishly asked for more clarification about the meaning of "situationism". Debord stood up and retorted in French, "We're not here to answer cuntish questions", and led the Situationists out of the room.[51]

As recounted in Atkins, *Asger Jorn*, 1977, p. 57.

---

## RESOLUTION

### OF THE FOURTH CONFERENCE OF THE SITUATIONIST INTERNATIONAL
### CONCERNING THE IMPRISONMENT OF ALEXANDER TROCCHI

The delegates to the fourth conference of the Situationist International, being informed of the arrest in the United States of their friend Alexander Trocchi, and of his charge of use of, and traffic in drugs, declare that the Situationist International retains full confidence in Alexander Trocchi.

The conference **DECLARES** that Trocchi could not have, in any case, traffic in drugs ; this is clearly a police provocation by which the situationist will not allow themselves to be intimidated ;

**AFFIRMS** that drug taking is without importance ;

**APPOINTS** Asger Jorn, Jacqueline de Jong and Guy Debord to take immediate action on behalf of Alexander Trocchi and to report upon such action to the Situationist International at the earliest moment ;

**CALLS** in particular upon the cultural authorities of Britain and on all British intellectuals who value liberty to demand the setting free of Alexander Trocchi, who is beyond all doubt England's most intelligent creative artist today.

London, 27th september 1960.

Poster of Alex Trocchi protesting his arrest, 1960.

## The Scission

The disagreements readily apparent at the London conference came to a head a year later at the fifth SI conference in Göteborg, Sweden in August 1961. It was the first conference without the recently resigned Jorn and the loss of his considerable negotiating skills soon became apparent.[52] <span style="font-size:smaller">He did, however, send a statement under the pseudonym of George Keller.</span> Debord was accompanied by two recent recruits, the Hungarian, but Brussels-based, Attila Kotànyi, and the Belgian school teacher Raoul Vaneigem. At the conference this Debordist faction faced criticism once again from the German section. Prem believed that the SI was missing its chance to make a huge impact on and through culture. An anonymous report paraphrased his comments:

The SI has no power but its power in culture–a power which could be very great and which is visibly within our reach. The SI majority sabotages the chances of an effective action on the terrain where it is possible. It castigates artists who would be able to succeed in doing something; it throws them out the moment they get the means to do things.

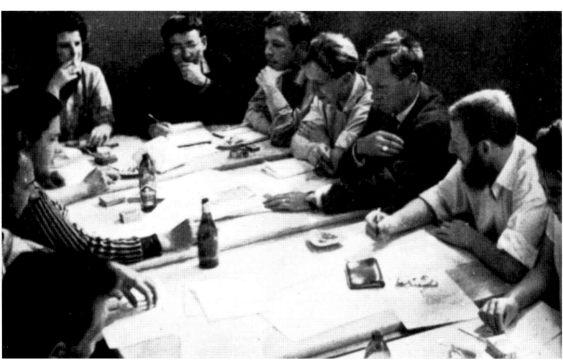

Left and right: The fifth conference of the SI in Gothenburg, August 1961.

The statement had come in response to Vaneigem's proposal that all art works produced by Situationists be described as antisituationist:

It is a question not of elaborating the spectacle of refusal, but rather of refusing the spectacle. In order for their elaboration to be *artistic* in the new and authentic sense defined by the SI, the elements of the destruction of the spectacle must precisely cease to be works of art. There is no such thing as *situationism* or a situationist work of art or a spectacular situationist.

To restate the point Kotányi added:

While various confused artists nostalgic for a positive art call themselves situationist, antisituationist art will be the mark of the best artists, those of the SI, since genuinely situationist conditions have as yet not at all been created. Admitting this is the mark of a situationist.[53]

Anon, "The Fifth SI Conference in Göteborg", in Knabb, *SI Anthology*, 1981, pp. 88-9.

The Debordist SI's position was that eventually everyone would be an artist, "in a sense which artists have never before achieved–in the sense that everyone will construct his own life."[54] Surprisingly, given these fundamental

Anon, "Manifeste, Le 17 mai 1960", *IS*, no. 4, June 1960, p. 38.

disagreements over the status of art, Debord did consent to add his signature, alongside that of other delegates, to a collective painting made during the conference.[55]

This painting is now in the collection of the Hallands Museum, Halmstad, Sweden.

The compromise agreement reached during the conference was superseded in February 1962 when the SI's Central Council controlled by Debord decided to exclude the Spurists (Erwin Eisch, Renée Nele, Fischer, Kunzelmann, Prem, Stadler, Sturm and Zimmer). A month later they were

Anon, "The Avant-garde of Presence", Knabb, *SI Anthology*, 1981, p. 109. Inventing and apportioning insults was a favourite activity of the SI. Amongst its most popular were: cretin, hypocrite, idiot, pimp, scoundrel, necrophage, confusionist, reformist, Trotskyist, Bourbuibist, sub-Leninist, stalino-surrealist, coagulated undertaker's mute, and monogamous police hound. John Cage was a "Buddhist Mental retard" and Sartre "a moneygrubbing commodity and mangy dead dog". See Hussey, *The Game of War*, 2001, p. 70 and for a full list see Jean-Jacques Raspaud and Jean-Pierre Voyer, *L'Internationale situationniste: chronologie, bibliographie, protagonistes (avec un index des noms insultés)*, Paris: Éditions Champ Libre, 1972.

Up to this date Martin's main contribution to the movement had been to supply the illustrations for a book of poetry by Nash. See Jørgen Nash, *Hanegal, gallisk poesiealbum*, Paris: Édition Internationale situationniste, 1961. The cover is made out of cardboard and wire, and the title translates as *The Cock's Crow*.

joined by the Nashists (Elde, Nash, and Jacqueline de Jong). Nashism (a term coined by JV Martin) immediately entered the SI lexicon as a term of abuse for "those who proclaim themselves situationists without having any idea of what they're talking about".[56] The excluded members de Jong, Nash and Elde quickly produced a tract denouncing their expulsion and complaining that "an organisation whose essential decisions are not based on the principle of debate is totalitarian and does not agree with our rules of collaboration".[57] With the Scandinavian section decimated its control was handed over to its sole survivor based in Randers, Denmark, JV Martin.[58]

Reprinted in *Situationist Times*, no. 1, 1962.

JV Martin, c. 1963.

In the years between 1962 and 1970 Martin edited three issues of the officially sanctioned journal *Situationistisk Revolution* and, exceptionally, remained a member of the SI until its dissolution in 1972.

# The Second Situationist International

The excluded Scandinavian members reformed and based themselves at a farm named Drakabygget (Dragon's Lair) in Örkelljunga in Sweden. Drakabygget had been purchased in September 1960 by Nash as the base for a new Situationist Bauhaus.[59] From 1962 onwards it

See Jean Sellem ed., "Bauhaus Situationist", a special issue of *Lund Art Press*, vol. 2, no. 3, 1992.

Jørgen Nash and Gordon Fazakerley at Drakabygget, 1962.

became the hub for a network of other informal organisations including the Second Situationist International, Co-Ritus, and the journal *Drakabygget*. The farmhouse acted as an artists' community and experimental workshop, and welcomed newcomers such as the English painter and poet Gordon Fazakerley, and the Danish painter, poet and filmmaker, Jens Jørgen Thorsen, co-founder with Nash of

Signatories of the "Co-Ritus-Manifest" of 1962 were Thorsen, Strid, Nash and Ambrosius Fjord (actually Nash's horse). The manifesto was published to coincide with an exhibition at Gallery Jenson in Møntergade and was later back-dated by Thorsen.

the Co-Ritus movement.[60] The pair aimed to replace spectators with participants and in line with the Second Situationist International also held that membership was not exclusive; anybody could become a Situationist, even ex-Situationists, like the artists of the Spur

Spur also went on to have connections with Kommune I in Berlin and the artist groups Wir (We) 1959-65, Geflecht (Network), 1965-68, and Kollektiv Herzogstrasse, 1975-82. Its last group exhibition as Spur took place at Galerie van de Loo in 1965.

group.[61] De Jong also visited Drakabygget and produced work there while working as editor and publisher of *The Situationist Times*.[62]

In 1964 Nash wrote about the group's philosophy for the *Times Literary Supplement*:

Six issues of this journal would appear between 1962 and 1967, with special issues being devoted to such esoteric topics as knots and labyrinths. The journal was edited by de Jong from Hengelo near the German border in Holland. After her association with the Second Situationist International finished in the early 1970s she continued her work as an artist, including the painting of a mural for the Nederlandse Bank and Amsterdam Town Hall. A retrospective of her work took place at the Cobra Museum, Amstelveen in June 2003. See Adrian Dannatt, "Undercover Agent", *The Guardian*, 7 June 2003.

The point of departure is the dechristianisation of Kierkegaard's philosophy of situations. This must be combined with British economic doctrines, German dialectic and French social action programmes. It involves a profound revision of Marx's doctrine and a complete revolution whose growth is rooted in the Scandinavian concept of culture. This new ideology and philosophical theory we have called situology. It is based on the principles of social democracy in as much as it excludes all forms of artificial privilege.[63]

Nash, Jørgen, "Who Are The Situationists?", *Times Literary Supplement*, no. 3262, 3 September 1964, p. 782-3.

The form that situology took in culture most closely resembled that of street theatre. Representative works included the painting of slogans and murals on a wooden fence in Copenhagen in 1962 (entitled *The Battle Against*

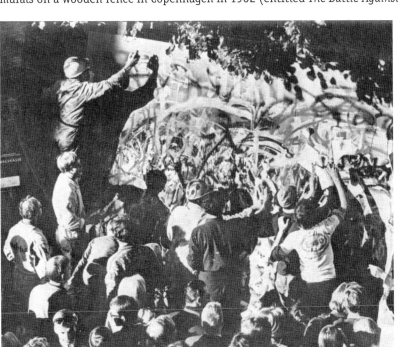

Collective painting at The Freedom of Expression is not for Sale street protest, Copenhagen, 1965.

Jaqueline de Jong.

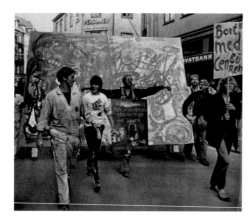

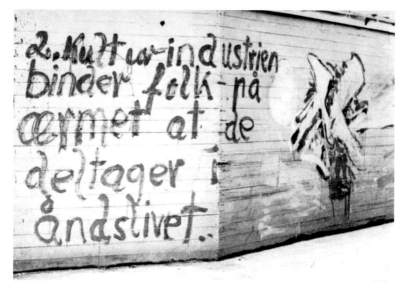

Top left:
Bjane "Cæsar"
Rasmussen and
JJ Thorsen, *Urbanistisk
Co-Ritus for 3000
persons* at The Freedom
of Expression is not
for Sale street protest,
Copenhagen, 1965.

Top right:
Gordon Fazakerley,
1962.

Bottom:
Hardy Strid painting
and slogans at a Co-
Ritus action outside
Gallery Jensen,
Copenhagen, 1962.

the *Grey, Dull City*) and the *Demonstration For the Freedom of Expression*
in August 1965, when the protesting artists were joined on the streets of
Copenhagen by 300 folksingers, jazz musicians and the police. In February
1963 the group collaborated on the exhibition The Spiral Labyrinth in Malmö
Town Hall as part of the international art show Facett 63 and issued a
manifesto attacking the Debordist faction of the SI as "a lamb-like pious
group that never pursued anything more than theoretical discussions".
"It is true", they added, "that the Drakabygget group was the most radical
in the sense that they wanted to realise what the others only talked about."[64]
The most infamous act associated with the group was the decapitation in
1964 of the Little Mermaid bronze sculpture at the entrance to Copenhagen
harbour. Although it is unclear exactly what role, if any, they played in the
theft they were not shy in courting attention from both the press and the

Quoted in Howard Slater, "Divided We Stand", http://www.infopool.org.uk/2001.html

police. Nash went as far as to deposit a black box, about the size and weight of the Mermaid's head, in the Royal Library in Copenhagen in 1981 with the condition that it should not be opened for 50 years.[65] Successful actions outside of Scandinavia included the occupation of the Swedish pavilion at the Academia de Belli Arte during the tumultuous Venice Biennale of June 1968 and the creation of an 'art barricade' outside the Kunsthalle Fridericianum in Kassel, Germany during the Documenta of 1972. Howard Slater described them

Situationister i konsten
(Situationists in
the arts), catalogue,
Varberg, 1966.

For more on the group's early activities see Carl Magnus et al, *Situationister i konsten*, Örkelljunga: Bauhaus situationiste, 1966 and Ambrosius Fjord and Patric O'Brien, *Situationister 1957-70*, Vanlöse, Eksp., Concord, Jyllingevej 2, 1970.

as "theoretical expressionists", a phrase that neatly sums up their rejection of doctrines and commitment to experiment and self-expression in all areas of every-day life. The various histories of the SI that dismiss this strand of the movement miss a great deal of what actually made the movement vital and visible in its time. History is written by the victors, but in this case some argue that we have been too early in judging just who were the winners and losers in the great scission of 1962.[66]

For more on the Second Situationist International see the website Infopool at http://www.infopool. org.uk/2001.html

Jørgen Nash and Hardy Strid with the Little Mermaid, Copenhagen, c. 1964.

## SI Post-Scission

The departure of those within the movement most closely associated
with artistic activity, meant that the remaining members were free to pursue
a programme that dismissed art as a separate or special activity. The SI's aim
was to destroy the distinction between art and everyday life and transform
the largely uncoordinated assaults by the historical avant-garde into a coherent
revolutionary perspective. The end now was revolution and the means, the
development of a unified revolutionary praxis, the simultaneous realisation
and suppression of art. In a typically contrary gesture one of the first elements
of this programme took the form of an art exhibition. Organised by Martin,
Destruction of the RSG-6 took place at the Exi Gallery, in Odense, Denmark,
between 22 June and 7 July 1963.[67] As part of the exhibition Debord produced
The SI chose Odense because the Nashists had exhibited there the year before in an exhibition
entitled Seven Rebels.
slogans, or rather "directives" as he called them, painted directly on to framed
canvasses. These proclamations, he wrote in the catalogue, were intended "as
a simultaneous ridicule and reversal of that pompous academicism currently
in fashion which is trying to base itself on the painting of incommunicable
'pure signs'". One of the canvasses was a painting by Pinot-Gallizio upon which
Debord painted *Abolition du travail aliéné* ("Abolition of Alienated
Labour"), as a graffiti on a wall. The work was mentioned in the local press
because the graffiti had apparently reduced the value of the work from 3,000
Danish Kroner down to just 300.

JV Martin with one
of Guy Debord's
directives: "Realise
philosophy", 1963.

Martin showed a series of 'thermonuclear cartographs' representing the affects of a future world war, while Bernstein exhibited three collage-like constructions of battle scenes with titles that transformed revolutionary defeats into victories (i.e. *Victory of the Commune of Paris*, *Victory of the Spanish Republicans*, and *Victory of the Great Jacquerie in 1358*). This reversal, wrote Debord, "corrects the history of the past, rendering it better, more revolutionary, and more successful than it ever was".[68] In 1967 Vaneigem singled out these works as an example of the first tentative steps for an art of agitation and propaganda:

Debord, Guy, "The Situationists and the New Forms of Action in Politics or Art", in Sussman, *On the Passage*, 1989, p. 153. Much of this work was destroyed when Martin's house was attacked by arsonists in March 1965.

These works stood for a dereification of particular historical events. They tended at once towards two goals: the rectification of the history of the workers' movement and the realisation of art. No matter how limited and speculative, agitational art of this kind opens the door to everyone's creative spontaneity, if only by proving that in the particular distorted realm of art subversion is the only language, the only kind of action, that contains its own self-criticism. There are no limits to creativity. There is no end to subversion.[69]

Vaneigem, Raoul, *The Revolution of Everyday Life*, Seattle, Washington and London: Left Bank Books and Rebel Press, 1983, p. 206.

The title of the exhibition referred to the recent publication of the English tract "Danger! Official Secret RSG-6", written by Spies for Peace, a direct action group dedicated to revealing the location of, and secret plans for, government-run nuclear fallout shelters. The exhibition catalogue contained an important text in which Debord, in the light of the recent expulsions, outlines his new vision of the SI's relationship to cultural production. Entitled "The Situationist International and the New Forms of Action in Politics or Art", the text described the group as acting simultaneously as "an artistic avant-garde, as an experimental investigation of the free construction of daily life, and finally as a contribution to the theoretical and practical articulation of a new revolutionary contestation".

In opposition to simplistic notions of prioritising politics above art or vice-versa, Debord posited a "unified vision of art and politics". The goal was unitary urbanism, and in the production of 'critical art' the key tool remained *détournement*. "Critical in its content", Debord wrote, "such art must also be critical of itself in its very form. Such work is a sort of communication that, recognising the limitations of the specialised sphere of hegemonic communication, will now contain its own critique."[70]

Debord, Guy, "The Situationists and the New Forms of Action in Politics or Art", in Sussman, *On the Passage*, 1989, pp. 148-153.

This text and the exhibition it accompanied were an obvious sign that the SI was not about to totally abandon the artistic sphere.[71] It is also significant that the SI never gave up the self description of itself as an avant-garde and in this sense comments made two years before the exclusions of the Germans and Scandinavians remain just as relevant in 1962: "Do we think that in leaving the SI they have broken from the avant-garde?

Martin would organise another exhibition by members of the SI in March 1967 in Århus, Denmark. Operation Playtime included work by Bernstein and five 'Nothing Boxes' by Viénet. Martin's contribution was a series of works entitled *Golden Fleet*, that included model ships stuck to canvases and copiously sprayed with metallic paint. The catalogue was published as a special edition of *Situationistisk Revolution*, no. 2.

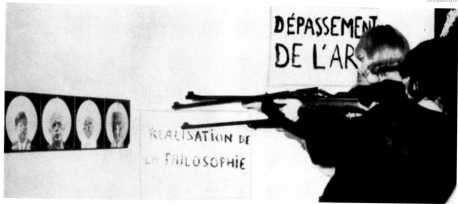

Publicity photograph from the exhibition Destruction of RSG-6, Odense, 1963.

Yes, we do. There is, for the moment, no other organisation constituted for a task of this scope."[72] As an organisation the SI now sought to

Anon, "The Adventure", in Knabb, *SI Anthology*, 1981, p. 60. First published in *IS*, no. 5, December 1960.

restructure itself around a much smaller central core of members based in Paris. It refused the temptation to become a mass movement and consciously turned away self-proclaimed disciples: "the SI can only be a Conspiracy of Equals, a general staff that *does not want troops. ... We will only organise the detonation*: the free explosion must escape us and any other control forever."[73] Thus the question of organisation became increasingly important,

Anon, "The Countersituationist Campaign in Various Countries", in Knabb, *SI Anthology*, 1981, p. 113. First published in *IS*, no. 8, 1963.

not least because it was one of the few factors under the group's control. Individual concerns were therefore subsumed under the ideals of the group and any discordant features were removed, with extreme prejudice, and with "no useless leniency" as Bernstein chillingly put it.[74]

Bernstein, Michèle, "No Useless Leniency", in Knabb, *SI Anthology*, 1981, pp. 47-8. First published in *IS*, no. 1, June 1958.

During the 1950s and 60s a great deal of activity within art history went into the historicizing of the avant-garde. Major publications and retrospective exhibitions on the pre war movements (Futurism, Dada, Russian Constructivism and Surrealism) had a telling impact on their post war descendants. The SI noted with admiration "the richness of supersession implicitly present albeit not fully realised in the 1910-1925 period", but

PROCHAINEMENT SUR LES ÉCRANS

PORTRAIT D'IVAN CHTCHEGLOV

LES ASPECTS LUDIQUES MANIFESTES ET LATENTS DANS LA FRONDE

ÉLOGE DE CE QUE NOUS AVONS AIMÉ DANS LES IMAGES D'UNE ÉPOQUE

PRÉFACE A UNE NOUVELLE THÉORIE DU MOUVEMENT RÉVOLUTIONNAIRE

DES FILMS ÉCRITS ET RÉALISÉS PAR GUY DEBORD

Guy Debord, *Contre le cinema* (*Against Cinema*), 1964.

at the same time criticised contemporary artists for "doing art as one

Anon, "Questionnaire", in Knabb, *SI Anthology*, 1981, p. 139. First published in *IS*, no. 9, August 1964.

does business".[75] From its start, however, the SI provided a critique of the avant-garde that negotiated, and attempted to resolve, many of the criticisms of these earlier movements, especially the bourgeoisie's ability

See Debord, "Report On the Construction of Situations and on the International Situationist Tendency's Conditions of Organization and Action" in Knabb, *SI Anthology*, 1981, pp. 18-22.

to channel the avant-garde's critical and experimental research toward strictly compartmentalised utilitarian disciplines.[76]

The SI, of course, was not alone in this. The 1950s and 1960s witnessed an unprecedented assault by the avant-garde on the dominance of painting and sculpture. The gallery as a container and frame for art was also questioned and led to developments such as land art, site specific installations and happenings. There was also a shift in the status of theory as a form of cultural production. The theoretical art work, which did not have to exist outside its description, broke down the separation between art and philosophy and between art objects and interpretation and led to what we now know as conceptual art.

It is possible to trace a similar development in the SI, from an art object-based movement to a theory-based movement. From the 1962 schism onwards the SI's work became constituted almost entirely in text, with the artist metamorphosed into a theorist of revolution. In his film *La Société du Spectacle* Debord favourably quotes August von Czieszkowski on this subject:

Thus, after the immediate production of art had ceased to be the most eminent activity and the predicate of eminence has shifted to theory as such, at present it has detached itself from the latter to the extent that there has developed a post-theoretical, synthetic practice whose primary purpose is to be the foundation and truth of both art and philosophy.[77]

Debord, Guy, *Society of the Spectacle and Other Films*, London: Rebel Press, 1992, p. 71.

This turn to theory became the focus of the group in the immediate years following the expulsion of the Nashists and Spurists. In an important text of 1964 that outlined the history and future programme of the SI, Bernstein let it be known that no less than three books of theory were in the course of completion: Vaneigem's *Traité de savoir-vivre à l'usage des jeunes generations* (*The Revolution of Everyday Life*), Debord's *La Société du Spectacle* (*The Society of the Spectacle*) and Rudi Renson's *L'Architecture et le Détournement* (*Architecture and Détournement*).[78] Unfortunately, Renson's book never appeared, but Debord and Vaneigem's works were about to change the members of the SI from obscure avant-garde non-entities into the hidden masters of a movement to overthrow the French state.

Bernstein, Michèle, "The Situationist International", *Times Literary Supplement*, no. 3262, 3 September 1964, p. 781.

# The
## chapter three
# Beginning
# of an Era
# 1966–1968

## The Society of the Spectacle and
## The Revolution of Everyday Life

It would be another three years before Bernstein's promised books
of Situationist theory appeared. On 14 November 1967 Éditions Buchet-
Chastel published Debord's *La Société du Spectacle* (*The Society of the Spectacle*),

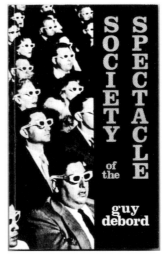

Front and backcover
of Guy Debord's
*The Society of the
Spectacle*, 1987.

and just two weeks later on 30 November Gallimard published Vaneigem's

*Traité de savoir-vivre à l'usage des jeunes générations* (*The Revolution of*

Debord, Guy, *La Société du Spectacle*, Paris: Éditions Buchet-Chastel, 1967; and Raoul Vaneigem, *Traité de savoir-vivre à l'usage des jeunes*

*Everyday Life*).[1] The significant critical response to both books belied the

*générations*, Paris: Gallimard, 1967.
The latter was translated by Donald
Nicholson-Smith as *The Revolution
of Everyday Life*, Seattle, Washington
and London: Left Bank Books
and Rebel Press, 1983. By the time
of these books' first publication
Bernstein had already resigned from
the group (in June 1967) but she
continued as a clandestine member
for another three years.

obscure status of their authors. This attention can be partly explained by

their association with the SI and its then current involvement with the

student unrest affecting the University at Strasbourg. Most reviews were

hostile (Pierre-Henri Simon in *Le Monde* called them "Saint-Justs in black

leather jackets") but the occasional review showed a more sympathetic

See Hussey, *The Game of War*, 2001, p. 219.

opinion.[2] Amongst these was an anonymous review in the *Times Literary

Supplement*:

M Debord and M Vaneigem have brought out their
long-awaited major texts: the *Capital* and *What Is
To Be Done?*, as it were, of the new movement. This
comparison is not meant mockingly. ... Under the
dense Hegelian wrappings with which they muffle
their pages several interesting ideas are lurking.

M Debord and M Vaneigem are attempting, for the first time, a comprehensive critique of alienated society.... Their austere philosophy, now authoritatively set forth, may not be without influence on future Committees of 100, Declarations of the 121, and similar libertarian manifestations.[3]

*Times Literary Supplement*, 21 March 1968. Quoted in "The Blind Men and the Elephant", in Knabb, *SI Anthology*, 1981, p. 383. The Committee of 100 and the Declaration of the 121 refer to groups within the Anti-Nuclear movement.

In *The Society of the Spectacle* Debord describes in 221 theses a society devastated by the shift from use-value and material concreteness to exchange value and the world of appearances: "The spectacle corresponds to the historical moment at which the commodity completes its colonisation

Debord's book was first clandestinely translated into English and published in Detroit by Black & Red in 1970. This original translation has been much criticised and contributed to the notion that Situationist theory was obscure and unfathomable. The latest edition, translated by Donald Nicholson-Smith (a brief member of the SI during the 1960s), is authorised and vastly improved. It also provided the opportunity for Debord to pick up some royalties (the first edition had a "no copyright" statement). All quotations are taken from this latest edition: Guy Debord, *The Society of the Spectacle*, New York: Zone Books, 1994.

of social life" (thesis 42).[4] As a summation and synthesis of Debord's thought the book contains substantial accounts of the spectacle, unitary urbanism, and the revolutionary role of workers' councils. In its terminology it shows the influence of Georg Lukács's *History and Class Consciousness*, especially

Lukács, Georg, *History and Class Consciousness*, London: Merlin Press, 1983.

his meditations on reification and the commodity-structure.[5] It also draws on the philosophy of Georg WF Hegel, the young Karl Marx, and later theorists such as the Dutch Marxist, Anton Pannekoek, particularly the latter's writings

Pannekoek, Anton, *Workers' Councils*, San Francisco; Stirling: AK Press, 2003.

on workers' councils.[6] Debord's bold ambitions for the book are apparent from the first paragraph with his *détournement* of Marx's opening of *Capital* (with Debord's "spectacle" replacing Marx's "commodity"): "The whole life of those societies in which modern conditions of production prevail presents itself as an immense accumulation of spectacles. All that once was directly lived has

Later in the book Debord provides a justification for this strategy of plagiarism: "Ideas improve. The meaning of words has a part in the improvement. Plagiarism is necessary. Progress demands it. Staying close to an author's phrasing, plagiarism exploits his expression, erases false ideas, replaces them with correct ideas" (thesis 207). Detailed analyses of *The Society of the Spectacle* and its borrowings from various authors can be found in Len Bracken, *Guy Debord: Revolutionary*, Venice, CA: Feral House, 1997, pp. 128–157 and Anselm Jappe, *Guy Debord*, Berkeley, CA: University of California Press, 1999, pp. 4-19.

become mere representation" (thesis 1).[7] The society of the spectacle was, by Debord's reckoning, born during the mid-1920s. Since that time it has come to encompass much more than the mass media of film and television, "rather, it is a social relationship between people that is mediated by images" (thesis 4). We are defined by our status as observers and as such the spectacle "is the opposite of dialogue" (thesis 17), precluding genuine communication, its only guarantee the manufacture of alienation (thesis 32). Frozen in a passive contemplation of what the spectacle has to offer (and what the spectacle has to offer is everything and nothing), its power rests in a command of an illusory unity of a social life grounded in mere appearance (thesis 10).

Art, for Debord, offers little hope of salvation or escape. The work of art, like the spectacle, is nothing but "capital accumulated to the point where it becomes image" (thesis 34). But its special status enables it to be recognised as the product that helps sell all the others: "A culture now wholly commodity was bound to become the star commodity of the society of the spectacle" (thesis 19). Within this context Debord sets out the SI's cultural strategy, to be the avant-garde of its own disappearance:

Dadaism sought to abolish art without realising it, and surrealism sought to realise art without abolishing it. The critical position since worked out by the Situationists demonstrates that the abolition and the realisation of art are inseparable aspects of a single transcendence of art (thesis 191).

The coming years did little to dampen Debord's disdain for what passed as 'culture' in spectacular society. In the later *Comments on the Society of the Spectacle* he provides this definitively damning judgement on art and artists:

Since art is dead, it has evidently become extremely easy to disguise the police as artists. When the latest imitations of a recuperated neo-dadaism are allowed to pontificate proudly in the media, and thus also to tinker with the decor of official palaces, like court jesters to the king, it is evident that by the same process a cultural cover is guaranteed for every agent or auxiliary of the state's networks of persuasion. Empty pseudo-museums, or pseudo-research centres on the work of nonexistent personalities, can be opened just as fast as reputations are made for journalist-cops, historian-cops, or novelist-cops.[8]

Debord, Guy, *Comments on The Society of the Spectacle*, Sheffield: Pirate Press, 1991, p. 20. Translation by Malcolm Imrie.

Comic of Guy Debord's *The Society of the Spectacle*.

that, for the first time, theory

as intelligence of human practice must be recognised and lived by the masses.

Thus it demands more of men without quality

than the bourgeois revolution demanded of the qualified men to whom it delegated its realisation

in which this class was already in power.

The very development of class society to the point of the spectacular organisation of non-life thus leads the revolutionary project to become visibly what it was already essentially.

Debord concludes *The Society of the Spectacle* with the statement that liberation from the spectacular society cannot be won "until individuals are directly bound to universal history; until dialogue has taken up arms to impose its own conditions upon the world" (thesis 221).

Since its first publication in 1967 Debord has supplemented the book with new prefaces, a 'comment', and even a feature length film. In the preface to the Italian edition he included a reflection on the varying qualities of translations of his work alongside thoughts on terrorism, the Italian State and Stalinism. The intervening years had done nothing to dampen Debord's faith in the imminent end of the spectacular society: "The days of this society are numbered; its reasons and its merits have been weighed in the balance and found wanting; its inhabitants are divided into two parties, one of which wants this society to disappear."[9] A more extensive reconsideration of recent developments in the spectacle appeared in *Commentaire sur la société du spectacle* (*Comments on the Society of the Spectacle*) published in 1988.[10] Here, Debord described how the competing realms of the spectacle, the "concentrated" and the "diffuse" (crudely characterised as the former Eastern Bloc and Western capitalism, respectively) had now combined into the "integrated" spectacle. This incredibly complex process was later summed

First published: Debord, Guy *Préface à la quatrième édition italienne de 'la société du spectacle'*, Paris: Éditions Champ Libre, 1979. Translated by Michel Prigent and Lucy Forsyth as *Preface to the Fourth Italian Edition of 'The Society of the Spectacle'*, London: Chronos Publications, 1979.

Debord, Guy, *Commentaire sur la société du spectacle*, Paris: Éditions Champ Libre, 1988. Translated by Malcolm Imrie as *Comments on the Society of the Spectacle,* London: Verso, 1990.

Raoul Vaneigem and
JV Martin, c. 1962.

See Debord in his "Preface to the Third French Edition", in Guy Debord, *The Society of the Spectacle*, New York: Zone Books, 1994, p. 10.

up for us in the repeatedly shown imagery of the fall of the Berlin Wall.[11]

The integrated spectacle is dominated by secrecy, 'official' and otherwise, and in this secret society of the spectacle the model for capitalist enterprises

Debord, *Comments*, 1991, p. 17.

is the Mafia.[12]

In contrast to the cool classicism of Debord's prose style Vaneigem's *The Revolution of Everyday Life* is written in an impassioned style with much use of allegory and poetic imagery. Tellingly, it was passages from Vaneigem's text rather than Debord's that activists sprayed on Parisian walls during May '68 and that the London-based terrorist group, the Angry Brigade borrowed for its communiqués in the early 70s.[13] Vaneigem splits his text into 25 chapters and two main sections: "Perspective of Power" and "The Reversal of Perspective". The former examines the present state of decomposition and the latter suggests some remedies for its final cure. In an early section Vaneigem pays homage to those that have written "works in the ink of action" and that have influenced his ideas on revolution. To readers of *IS* his list included many familiar figures: "Sade, Fourier, Babeuf, Marx, Lacenaire, Stirner, Lautréamont, Léhautier, Vaillant, Henry, Villa, Zapata, Makhno, the Communards, the insurrectionaries of Hamburg, Kiel, Kronstadt, Asturias".[14] Also featuring strongly in the book are the French dramatist Antonin Artaud, the anarchists Jules Bonnot and Buenaventura Durruti, the German psychoanalyst Wilhelm Reich, and James Joyce, "the man of total subjectivity", whose book *Ulysses* Vaneigem described as "the *Capital of individual creativity*".[15]

The concept of everyday life so central to the book drew significantly on the work of Henri Lefebvre, in particular his *Critique de la vie quotidienne* (*Critique of Everyday Life*).[16] During the period between 1957 and 1961, Lefebvre was very close to the Situationists and later described how he regularly visited Debord and Bernstein's flat to discuss theories of everyday life and unitary urbanism, often over a glass of tequila. Debord even agreed to take part in one of Lefebvre's seminars, albeit via a pre-recorded message.[17] True to form, the relationship did not last and when Debord claimed in 1963 that Lefebvre had plagiarised a SI text on the Paris Commune the relationship ended. "In the end it was a love story that ended badly, very badly", Lefebvre said. "There are love stories that begin well and end badly. And this was one of them."[18] The end of the affair did not mean that the concept of the everyday was no longer of use to Debord and Vaneigem. The everyday remained just as much a site of contestation as the workplace or the political arena. The roles played and the commodities consumed in everyday existence constituted key

On connections between the Angry Brigade and the SI see Sadie Plant, *The Most Radical Gesture: The Situationist International in a Postmodern Age*, London: Routledge, 1992, pp. 125-7 and Hussey, *The Game of War*, 2001, pp. 312-14.

Vaneigem, *The Revolution*, 1983, p. 45-6.

Vaneigem, *The Revolution*, 1983, p. 131.

Lefebvre, Henri, *Critique de la vie quotidienne*, 3 vols., Paris: L'Arche, 1947-1981.

See Guy Debord, "Perspectives for Conscious Alterations in Everyday Life", in Knabb, *SI Anthology*, 1981, pp. 68-75. First published in *IS*, no. 6, August 1961.

Ross, Kristin, "Lefebvre on the Situationists: An Interview", in McDonough, *Guy Debord*, 2002, p. 268.

elements in their revolutionary theory. As Vaneigem explained: "Guerrilla war is total war. This is the path on which the Situationist International is set: calculated harassment on every front–cultural, political, economic and social. Concentrating on everyday life will ensure the unity of the combat."[19]
<sub>Vaneigem, *The Revolution*, 1983, p. 204.</sub>

Vaneigem opens his book with a passage likening contemporary existence to a Walt Disney cartoon character who rushes over the side of a cliff and for a moment hangs suspended in mid-air only to fall to the ground as soon as he realises his predicament. It is the forces of repression in a society of mere survival that maintain this false state of suspension. Against them Vaneigem presents a set of counter-strategies, including active participation, freedom from work, an end to self-sacrifice, self-determination, the realisation of creative potential, and the valorisation of spontaneity and play. On this last topic he describes how contemporary society forbids play, or confines it to the world of childhood alone. For Vaneigem the pursuit of play and games promises a world of "masters without slaves", an end to hierarchies and social separation, and the rejection of fixed roles: "the true game and the revolution of everyday life are one".[20] In this world rules still exist, but they are continually broken. Cheating is enshrined as a legitimate means to inventing the new games of a better life to come.
<sub>Vaneigem, *The Revolution*, 1983, p. 200.</sub>

Despite the supposed disavowal of artistic strategies during the scission of 1962, Vaneigem still reserves a special role for both poetry and art in his new model of subversion. By poetry he does not mean a special arrangement of words composed on paper, but the production and organisation of creative spontaneity in everyday life, in the "language of the deed": "Poetry is also radical theory completely embodied in action; the mortar binding tactics and revolutionary strategy; the high point of the great gamble on everyday life."[21] The reinvention of life is not dictated by theorists but evolves out of "poetic creation", despite the specialists of revolution: "This revolution is nameless, like everything springing from lived experience. Its explosive coherence is being forged constantly in the everyday clandestinity of acts and dreams."[22]
<sub>Vaneigem, *The Revolution*, 1983, p. 154.</sub>
<sub>Vaneigem, *The Revolution*, 1983, p. 82.</sub>

As for the visual arts, Vaneigem looks back in admiration at the Dadaists and the historical avant-gardes of the period from 1910 to 1920, when many heroic attempts were made to merge art with everyday life, such

as with the Dadaists of the Cabaret Voltaire in Zurich. According to Vaneigem nothing had emulated these achievements, with the exception of Surrealism, until the formation of the SI in 1957. The only other 'movement' close in spirit to Dada is found in the sporadic outbursts of juvenile delinquency, in which he perceives "the same contempt for art and bourgeois values. The same refusal of ideology. The same will to live. The same ignorance of history. The same barbaric revolt. The same lack of tactics."[23] Another exception were the paintings of Giorgio de Chirico with their striking illustrations of the current state of spectacular pseudo-life:

Vaneigem, *The Revolution*, 1983, p. 138.

The blank faces of Chirico's figures are the perfect indictment of inhumanity. His deserted squares and petrified backgrounds display man dehumanised by the things he has made—things which, frozen in an urban space crystallising the oppressive power of ideologies, rob him of his substance and suck his blood.[24]

Vaneigem, *The Revolution*, 1983, p. 111.

According to Vaneigem the roles of artists and poets would eventually be subsumed under a "collective effort", thus ending art's dependence on specialisation: "There are no more artists because everyone is an artist. The work of art of the future will be the construction of a passionate life."[25] A big part of this passionate life would be love and the intimation it gives us of true communication. Vigilance, however, will be necessary because

Vaneigem, *The Revolution*, 1983, p. 155.

as communication in general tends to break down, love becomes increasingly precarious. Everything tends to reduce lovers to objects. Real meetings are replaced by mechanical sex: by the posturing of countless Playboys and Bunnies. True love is revolutionary praxis or it is nothing.[26]

Vaneigem, *The Revolution*, 1983, p. 192.

At the opposite end of the spectrum of human relations, on the question of what to do with those that stand in the way of the revolution, Vaneigem is brutally uncompromising: "humanism does not apply to

Left and right: Comic of Raoul Vaneigem's *The Revolution of Everyday Life*.

mankind's oppressors. The ruthless elimination of counter-revolutionaries is a humanitarian act because it is the only course that averts the cruelties of bureaucratised humanism."[27] In a postscript added in October 1972 Vaneigem describes his book as seeking "the shortest path from individual subjectivity to its actualisation in history-made-for-all. From the standpoint of the long revolution, it was a mere point–though possibly a point of departure–on the road towards communalism and generalised self-management."

Vaneigem, *The Revolution*, 1983, p. 204.

Typically, Vaneigem concludes the postscript with a stirring climax, describing the book as a "death sentence" on the society of survival: "We have a world of pleasures to win, and nothing to lose but boredom."[28]

Vaneigem, *The Revolution*, 1983, p. 216.

## May '68

By 1965 the SI's influence was growing. The print run of its journal rose from the hundreds to the thousands and although the core group remained firmly based in Paris its admirers could be found in many countries. The SI was likewise finding inspiration from events abroad, in particular the battle for Algerian independence. Begun by the FLN (National Liberation Front) in the mid-1950s the campaign would claim the lives of both Algerian nationalists and French colonists and in the process spark off the creation of the French rightwing terrorist group, the Organisation de l'Armée Secrète (OAS). The importance of the uprising for the SI was apparent from the first issue of *IS* with the unsigned text *"Une guerre civile en France"* ("A Civil War in France"). Military-backed repression in Algeria also had repercussions closer to home and Paris was often the site for violent anti-war and pro-Algerian mass demonstrations. In 1960 both Debord and Bernstein, along with other leftwing cultural figures, signed a *Declaration on the Right to Insubordination in the Algerian War*, which called on French soldiers to ignore orders to shoot Algerians.[29]

Further afield, the SI was particularly impressed by the example of the August 1965 riots in the black areas of Watts in Los Angeles. The events prompted the SI to write and publish, in late December 1965, the tract *The Decline and Fall of the Spectacular Economy*, in which it took up the challenge of defending the rioters in the "terms they deserve". According to the SI the rebellion in Los Angeles had not been a race riot but a class riot and its main

The SI's interest in Algerian affairs continued beyond the declaration of independence in 1962 and included, in 1965, two clandestinely distributed tracts protesting against the attack on the self-management movement after Boumedienne's military putsch deposed Ben Bella. For English translations see "Address to the Revolutionaries of Algeria and All Countries", Knabb, *SI Anthology*, 1981, pp. 148-152, and "The Class Struggles in Algeria", Knabb, *SI Anthology*, pp. 160-8.

target had been the destruction of the world of the commodity, with its main form of critique the act of looting, the act of taking without paying: "What American blacks are really daring to demand is the right to really live, and in the final analysis this requires nothing less than the total subversion of this society." The SI pointed out that the Watts rioters were not alone in their struggle and significantly (in terms of what was to come) pointed to the contestation being carried out by the students of Berkeley and the University of Edinburgh:

A revolt against the spectacle—even if limited to a single district such as Watts—calls *everything* into question because it is a human protest against a dehumanised life, a protest of *real individuals* against their separation from a community that would fulfil their *true human and social nature* and transcend the spectacle.[30]

Anon, *Watts 1965: The Decline and Fall of the Spectacular Economy*, Berkeley: Bureau of Public Secrets, 1992. First published in December 1965. Another translation in Knabb, *SI Anthology*, 1981, pp. 153-160.

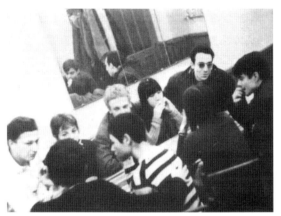

SI meeting, Paris, 1966.

Closer to home on 14 May 1966, pro-Situ students led by André Schneider at the University of Strasbourg were elected to run the local students' union, the *Association fédérative générale des étudiants de Strasbourg* (AFGES). They contacted the SI for advice about the best way to spend the union's money. Debord and Mustapha Khayati met the students and recommended they use it to print and publish a pamphlet to be written by Khayati. A few months later, in October, pro-Situ students at Strasbourg disrupted a lecture by the philosopher of cybernetics, Abraham Moles.

Pelting him with tomatoes the demonstration was part of an on-going war of attrition between the SI and Moles. A year before, on 24 March 1965, a group of SI influenced students disturbed a talk by Moles and the cybernetic sculptor Nicolas Schöffer, distributing the tract *La tortue dans la vitrine (dialectique du robot at du signal)* (*The Tortoise in the Tank: Dialectic of the Robot and the Signal*). For the demonstration in October one of the pro-Situ students, André Bertrand, produced the poster comic strip, *Le retour de la colonne Durruti* (*The Return of the Durutti Column*). This poster has since acquired iconic status with its exemplary use of *détournement* and its

The title drew on the legacy of a group of Spanish Anarchists led by Buenaventura Durruti during the Spanish Civil War. See Greil Marcus, "The Cowboy Philosopher", *Artforum*, March 1986, pp. 85-91.

humorous portrayal of cowboys discussing reification.[31] One of the aims of Bertrand's comic strip was to announce the forthcoming publication of "the most scandalous brochure of the century". Khayati gave his pamphlet (written under the close supervision of Debord), the self-explanatory title: *On The Poverty of Student Life Considered in its Economic, Political, Psychological, Sexual, and Particularly Intellectual Aspects, and a Modest Proposal for its Remedy*. As promised it was published wholly and expensively by the local

Situationist International and the AFGES, *De la misère en milieu étudiant, considérée sous ses aspects économique, politique, psychologique, sexuel et notamment intellectuel et de quelques moyens pour y remédier*, Paris: Association fédérative générale des étudiants de Strasbourg, 1966. The first English translation was published in London in 1967, translated by Donald Nicholson-Smith and TJ Clark and edited by Christopher Gray. A more recent English translation and the source of the following quotations was: *On the Poverty of Student Life*, London: Dark Star Press and Rebel Press, 1985.

AFGES in an edition of 10,000 copies.[32]

The text begins with the striking statement that the student, along with the priest and policeman, is "the most universally despised creature in France". The role of the student in modern capitalism is that of the initiate, preparing for his or her future role as a specialist in a culture of general passivity. They pass their time as conspicuous cultural consumers of

*On the Poverty of Student Life*, 1985, p. 9.

corpses and "anaemic gods": "Art is dead, but the student is necrophiliac."[33] Student struggles may begin with a rebellion against their studies, but these must quickly extend beyond such a limited field of action: "The student is a product of modern society, like Godard or Coca-Cola, his alienation can only

*On the Poverty of Student Life*, 1985, p. 11.

be contested by contesting the whole society."[34] They must also look to, and learn from, the mistakes of other dissident youth, such as the 'delinquents' (*blousons noirs*), who express their rejection of society through crime and violence, and the Provos of Amsterdam who had attempted to give delinquency a political form. Khayati then provides a history lesson on forms of revolutionary organisation culminating in the fine example of workers' councils. He then concludes with a description of the destruction of pseudo-needs through "the poetry of the future":

# LE RETOUR DE LA COLONNE DURUTTI

## ..car c'est cette concentration exclusive sur le monde réel qui produira une vie nouvelle et de nouveaux grands hommes de grands caractères et de grandes actions

Comme suite à cette victoire bientôt vous pourrez vous procurer, éditée par le bureau de l'A.F.G.E.S, la brochure la plus scandaleuse dusiè-cle. "De la misère en milieu étudiant considérée sous ses aspects économique, psychologique, politique, sexuel, et notamment intellectuel, et de quelques moyens pour y remédier" est un cardiogramme de la réalité quotidienne qui vous permettra de choisir vous-même votre bord, pour ou contre la misère présente, pour ou contre le pouvoir qui en vous prenant votre histoire, vous empêche de vivre.

## A VOUS DE JOUER

ASSOCIATION FEDERATIVE GENERALE DES "ETUDIANTS" DE STRASBOURG

*Le Retour de la Colonne Durutti* (*The Return of the Durutti Column*), comic strip, Strasbourg, 1966.

For the proletariat revolt is a festival or it is nothing; in revolution the road of excess leads once and for all to the palace of wisdom. A palace which knows only one rationality: the game. The rules are simple: to live instead of devising a lingering death, and to indulge untrammelled desire. [35]

*On the Poverty of Student Life*, 1985, p. 25.

The pamphlet was distributed on 22 November 1966, the official opening day of the university. The next day the pro-Situ students and Khayati held a press conference to explain their actions and to encourage further acts of disobedience amongst the students. Over the coming weeks the increasing disruption of student life at the university began to attract the national press. On 13 December the university authorities sought to halt the disorder by handing control of the AFGES over to the courts. Judge Llabrador suspended the students and in the course of his judgement provided a concise summary of the problems about to face France. The students, he claimed, were:

scarcely more than adolescents, lacking all experience of real life. Their minds confused by ill-digested philosophical, social, political and economic theories, and bored by the drab monotony of everyday life, they make the empty, arrogant and pathetic claim to pass definitive judgements on their fellow students, their teachers, God, religion, the clergy and the governments and political systems of the entire world. Rejecting all morality and constraint these students do not hesitate to commend theft. [36]

*On the Poverty of Student Life*, 1985, p. 3.

The press coverage portrayed the SI as secretive manipulators orchestrating events to serve its own insurrectionary ends. Although the SI stressed the autonomy of the students, it quickly realised the potential for publicity that such relatively small scandals could create. The label "Situationist" soon became a by-word for all types of extremist

and disaffected youth movements throughout Europe. The scandal also stimulated demand for translations of *On the Poverty of Student Life*–much against Debord's wishes, a new cult had been born. The SI, however, was under no illusions about the limitations of being media stars and even less about the significance of isolated student rebellions. At the time there were few indications that the events in Strasbourg would sow the seeds of a revolt that in the coming months would almost bring down the French government.

The SI did not have to wait long for the next stage in this process to begin. At the recently built University of Nanterre, just outside Paris, the students lived in overcrowded, poor housing and were subject to outmoded rules that forbid the free association of male and female students in each other's dormitories. Looking back, the SI described the scene at Nanterre as 'perfect': "The urbanism of isolation had grafted a university centre onto the high-rise flats and their complementary slums. It was a microcosm of the general conditions of oppression, the spirit of a world without spirit."[37]

Viénet, René, *Enragés and situationists in the occupation movement, France, May '68*. New York; London: Autonomedia; Rebel Press, 1992, p. 21.

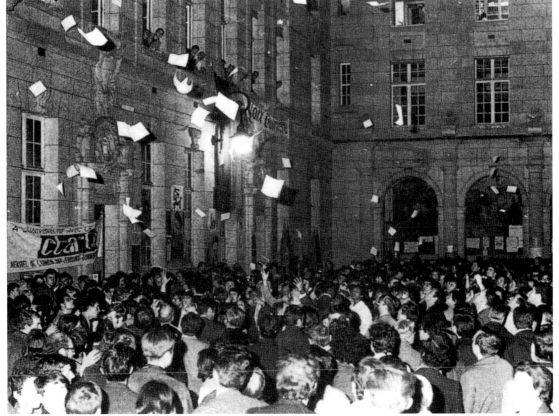

The SI distribute flyers at the university of Strasbourg.

The struggle continues, poster, May '68.

Student unrest at the University first took the form of strikes and the disruption of lectures. By January 1968 this had escalated into full-scale clashes with the police, and demonstrations against the presence of plain-clothes cops on the campus. One particularly fearless group of students was called the Enragés and led by the charismatic René Riesel. The Enragés were sympathetic to the Situationist viewpoint and helped distribute its pamphlets and tracts on the Nanterre campus.

On 22 March 1968 a variety of leftist groups occupied the University's administration building, but the Enragés soon departed when their demands to exclude 'Stalinists' and official observers were ignored. Before leaving the building, however, they left behind a selection of slogans for the assembly to consider: "Take your desires for reality", "Boredom is counter-revolutionary", and "Trade unions are brothels". Riesel and the Enragés now declared themselves at war with the University's authorities. In return, the University threatened Riesel, along with members of the recently formed March 22nd Movement, with expulsion. The March 22nd Movement counted amongst its spokesmen Daniel Cohn-Bendit, a young German student later magnani-

We are the State, poster, May '68.

mously described by the SI as "an honest but only mediocre revolutionary".[38]

Viénet, *Enragés and Situationists*, 1992, p. 23.

The events at Nanterre attracted sensational headlines and numerous exposés, many implicating the Situationists as dangerous agitators. On 29 March 1968, the Communist Party's newspaper *L'Humanité* described the "commando actions undertaken by a group of anarchists and 'situationists', one of whose slogans–in giant letters–"DON'T WORK!" decorated the entrance to the campus". How, they asked, had "a handful of irresponsible elements been able to provoke such serious decisions, affecting 12,000 students in the arts and 4,000 in law?"

May 68, Start of a prolonged struggle, poster, May '68

Cohn-Bendit and Riesel's expulsion tribunal was due to take place at the Sorbonne on Monday 6 May. The *Union Nationale des Étudiants Français* (UNEF) called a meeting to discuss tactics in fighting the expulsions on Friday 3 May. An excessive police presence and the arrival of the extreme rightwing student group, Occident, along with the *Compagnies Républicaines de Sécurité* (CRS) riot police, created an increasingly tense atmosphere. At the instigation of the Enragés, students prepared to defend themselves by breaking up furniture and distributing the dismembered parts for use as clubs and shields. Arrests were made and news of the disturbances quickly spread through the Latin Quarter's bars and cafés. The streets quickly filled with angry students calling for the release of their comrades. As the scuffles intensified the authorities took the almost unprecedented step of announcing the closure of the Sorbonne. In protest the lecturers and student unions called for an immediate strike.

On Monday, 6 May, Riesel, Cohn-Bendit and six other students arrived for their hearing before the Committee of the Institution of the University of Paris. They arrived to find the Sorbonne surrounded by an explosive mixture of riot police, political activists, and students. The SI was there, distributing its leaflet "La rage au ventre" ("Fire in the Belly") and pointing out that the "mere contestation of the bourgeois university is insignificant when it is all of society which must be destroyed". During the day the demonstration grew into a full-scale riot with approximately 10,000 demonstrators defending the area around the Place Saint-Germain-des-Prés. Cars were overturned and used as barricades and some shops were looted. The students did not act in isolation. Amongst the demonstrators were workers, the unemployed, high school students and *blousons noirs*. The rioters defended themselves against the police's tear gas and baton charges with paving stones and Molotov cocktails.

A week later, on 13 May, over a million workers and students took part in a mass demonstration in Paris. After the march some of the demonstrators broke off and decided to occupy the Sorbonne. Amongst them were the Enragés and the Situationists. On the next day they founded the Committee of the Enragés and the Situationist International. Situationist slogans began to appear on posters hastily pasted up throughout the

# LA BEAUTÉ
# EST DANS LARUE

Beauty is in the
street, poster,
May '68

building, one quoted Vaneigem: "Those who speak of revolution and class
struggle, with explicit reference to daily life, without understanding what
is subversive in love and positive in the refusal of constraints, have a corpse
Vaneigem, *The Revolution*, 1983, p. 15.
in their mouths!"[39] Only a poster calling for the destruction of the university
chapel and the "immediate dechristianisation of the Sorbonne" met with
strong enough disapproval to be torn down. At the first general assembly
of the occupiers a protracted discussion began about the aims of the dispute,
specifically whether it extended beyond university reform to include a total
social revolution. Riesel put forward the case for its expansion demanding
"the abolition of class society, wage labour, the spectacle, and survival".
Riesel argued that the question of university reform had long since become
Viénet, *Enragés and Situationists*, 1992, p. 49.
irrelevant: "exams had been cancelled at the barricades".[40]

   In the early days of the occupation the Committee of the Enragés
and the Situationist International reproduced the tract "Minimum Definition
of Revolutionary Organisations" (first circulated for discussion in July 1966
Viénet, *Enragés and Situationists*, 1992, pp. 131-2.
at the seventh SI Conference in Paris).[41] The SI sensed that its appointment
with history had come and part of its mission was to propagandise on
behalf of workers' councils. The call went out for all workers to occupy their
factories and work places. Debord had become a committed advocate of
workers' councils after his association with the *Socialisme ou barbarie* group,
which, along with its journal of the same name, was founded in 1949 by
Cornélius Castoriadis and Claude Lefort. Debord became involved with the
group in the autumn of 1959 although the only material product of this
association came in the form of a July 1960 text, co-written with Pierre
Canjuers (pseudonym of Daniel Blanchard), "Preliminaries Toward Defining
Knabb, *SI Anthology*, 1981, pp. 305-310.
a Unitary Revolutionary Programme".[42] Debord eventually broke with the
group in May 1961.

   The SI adopted much of *Socialisme ou barbarie*'s political theory,
from the characterisation of the Soviet Union as a state bureaucracy
in competition with Western state bureaucracies, to the idea of council-
communism, epitomised in the slogan "All power to the soviets!". According
to this theory the party should always be subordinate to the workers and
their autonomously formed councils. Revolution did not entail the taking
of state power, but rather the abolition of the state, or in SI terms, the

revolution of everyday life. The irony is that a movement founded on the cry of "Never Work!" should base its main political hopes on the formation of workers' councils. Debord had written extensively about the revolutionary role of workers' councils in *The Society of Spectacle*. In these councils alone do we find "the objective preconditions of historical consciousness" that open "the door to the realisation of that active direct communication which marks the end of all specialisation, all hierarchy, and all separation".[43]

Debord, *The Society of the Spectacle*, thesis 116.

You can imagine Debord's excitement when news reached him that the workers at the Sud-Aviation plant in Nantes had occupied their factory. If other workers followed their example then the historical crisis predicted by the SI might soon become reality. With an increasing number of wildcat strikes a general strike seemed inevitable, despite official trade union opposition. In fact much of the May '68 events took place without the support of the trade unions or the Communist Party, which through its newspaper, *L'Humanité*, and other forums, condemned the strikes, occupations, and demonstrations as the work of mere trouble-making "provocateurs". According to the SI, the trade unions of France were little more than "mechanisms for the integration of the proletariat into the system of exploitation".[44] Put simply, they could not to be trusted.

Viénet, *Enragés and Situationists*, 1992, p. 85.

On 16 May, the Sorbonne Occupation Committee sent a telegram of support to the Sud-Aviation workers and called for other workers to follow their example:

Comrades, the Sud-Aviation factory at Nantes has been occupied for two days by the workers and students of that city. The movement was extended today to several factories (NMPP-Paris, Renault-Cléon, etc). The Occupation Committee of the Sorbonne calls for the immediate occupation of all factories in France and the formation of workers' councils.[45]

Viénet, *Enragés and Situationists*, 1992, p. 53.

Later that day the largest factory of its kind, the Renault-Billancourt, entered the fray with a wildcat strike of its own.

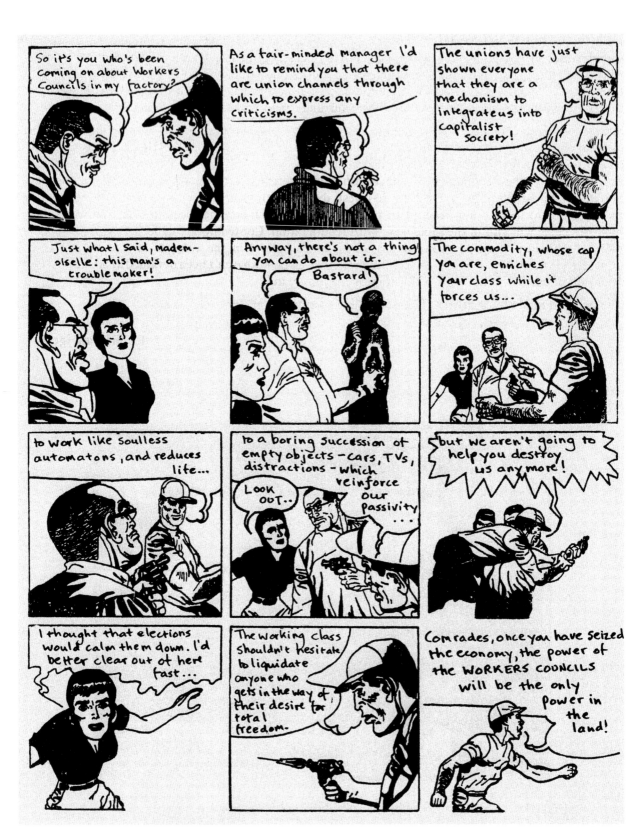

Illustration from Christopher Gray ed., *Leaving the Twentieth Century*, 1974.

It is difficult to calculate the effect these telegrams, and the various tracts put out by the SI, might have had on the events of May '68. When the SI is mentioned in accounts of that time it is chiefly as producers of inspirational slogans, graffiti, posters and comic strips. As early as 1961 Vaneigem had recognised these forms of agit-prop exclamations as a key means of expression for the group: "What sign should one recognize as our own? Certain graffiti, words of refusal or forbidden gestures inscribed with haste."[46] From an early stage the Occupation Committee recognised the value

Vaneigem, Raoul, "Commentaires contre l'urbanisme", *IS*, no. 6, August 1961, p. 35.

of slogans and encouraged their production and dissemination to the extent of providing guidance in tracts such as "Slogans to be Spread Now by Every Means", with its calls to "Occupy the Factories", "Power to the Workers' Councils", "Abolish Class Society", "Down with the Spectacle-Commodity Society", "Abolish Alienation", "Terminate the University", "Death to the Cops", and the satisfyingly inclusive "Humanity Won't be Happy Till the Last Bureaucrat is Hung with the Guts of the Last Capitalist".[47]

Viénet, *Enragés and Situationists*, 1992, p. 131. For more on this material see: Marc Rohan, *Paris '68: graffiti, posters, newspapers and poems of the events of May 1968*, London: Impact Books, 1988.

For the SI the events of May '68 represented the embodiment of Vaneigem's concept of poetry as radical theory in action. The Situationist René Viénet later described how, for the first time since the Commune of 1871, "millions of people cast off the weight of alienating conditions, the routine of survival, ideological falsifications, and the inverted world of the spectacle". It was the first "true holiday":

The hierarchical pyramid had melted like a lump of sugar in the May sun. People conversed and were understood in half a word. There were no more intellectuals or workers, but simply revolutionaries engaged in dialogue, generalising a communication from which only "proletarian" intellectuals and other candidates for leadership felt themselves excluded. … The streets belonged to those who were digging them up.[48]

Viénet, *Enragés and Situationists*, 1992, p. 76-7.

With the sudden suspension of the necessity of forced labour, creativity flowed freely in all spheres: "Everyone was thus able to measure the amount

of creative energy that had been crushed during the periods of survival, the days condemned to production, shopping, television, and to passivity erected as a principle."[49]

Viénet, *Enragés and Situationists*, p. 80.

This period of ecstatic optimism, however, was not destined to last and the "Slogans" tract marked the end of the SI's influence on the Sorbonne Occupation Committee. Arguments over the Committee's role became so great that the Situationists and Enragés decided to withdraw on 17 May, first to the nearby National Pedagogical Institute and then to the School of Decorative Arts. At the latter they formed the *Conseil pour le maintien des occupations* (CMDO), along with like-minded Enragés, workers, students and councilists, altogether forming a cadre of about 40 militants. Over the next few days the group produced the tracts "Report on the Occupation of the Sorbonne", 19 May, "Power to the Workers Councils", 22 May and "Address to All Workers", 30 May. The first of these concluded that the student struggle had been superseded and now it was up to the workers to spread even further the occupation of the factories. In "Power to the Workers Councils" the CMDO outlined its understanding of the situation:

In ten days, not only have hundreds of factories been spontaneously occupied by the workers and a spontaneous general strike totally disrupted the activity of the country, but, moreover, several buildings belonging to the state have been occupied by de facto committees who are taking control. In such a situation, which in any case can't last but which confronts the alternative of extending itself or disappearing, all the old ideas are swept aside and all radical hypotheses on the return of the revolutionary movement confirmed.

In the "Address to all Workers" the CMDO described the events in France as a wake-up call for the ruling classes of the world, from the bureaucrats of Moscow to the millionaires of Washington. The international proletariat was

Situationist comic,
San Francisco, 1971.

capable of seizing power in "every citadel of every alienation". The occupations movement, the tract explained, was not only threatening the economic order but also "the whole meaning of social life". What was now needed was a revolutionary consciousness:

> Those who turned down the ridiculous contract agreements offered to them (agreements that overjoyed the trade union leaders) have still to discover that while they cannot "receive" much more within the framework of the existing economy, they can *take everything* if they transform the very bases of the economy on their own behalf. The bosses can hardly pay more–but they could disappear.[50]

Viénet, *Enragés and Situationists*, pp. 134-9.

Other activities of the CMDO involved the production of comic strips, revolutionary songs and six posters (produced, like the tracts, by the IPN press, an occupied print shop at Montrouge).[51]

These included: *Down with the Spectacle-Commodity Society*; *Abolition of Class Society*; *Occupation of the Factories*; *End of the University*; *Power to the Workers Councils*; *What Can the Revolutionary Movement Do Now? Everything. What Does It Become in the Hands of the Parties and the Unions? Nothing. What Does the Movement Want? The Realisation of a Classless Society through the Power of the Workers Councils*. Asger Jorn also continued to show his Situationist sympathies with the belated production in June of four posters commemorating the revolutionary spirit of May '68: *Long Live the Passionate Revolution of Creative Intelligence*; *Smash the Frame that Stifles the Image*; *Support the Students Who Should Study and Learn Freely*; *No Power of Imagination Without Powerful Images*.

On 24 May, the French President, Charles de Gaulle, appeared on French national television but his intervention did little to calm the situation and instead it sparked off another round of rioting and an attack on the Paris Stock Exchange. De Gaulle's second appearance, on 30 May, was more successful and

proved to be the launch of a counter-revolutionary return to order. In the broadcast he announced a general election and appealed to French patriots to return to work. Like the judge at Strasbourg, de Gaulle's speechwriters were strikingly candid in their analysis of the causes behind the extraordinary show of disaffection:

This explosion has been provoked by groups in revolt against modern consumer and technical society, whether it be the Communism of the East, or capitalism in the West. They are groups, moreover, which have no idea at all of what they would replace it with, but who delight in negation, destruction, violence, anarchy, and who brandish the black flag.[52]

Viénet, *Enragés and Situationists*, 1992, p. 95.

The broadcast coincided with the gradual petering out of strike actions (helped no doubt by de Gaulle's promise of wage rises) and the beginning of the summer holidays with the annual mass exodus from Paris. Some student groups were banned and without clear leadership and a shared set of objectives, the movement impotently floundered. The Sorbonne was retaken by the police on 16 June and despite the optimism of its tract of 8 June, "It's Not Over!", the CMDO dissolved itself at the end of its final meeting on 15 June. Viénet later wrote:

The CMDO had never tried to get anything for itself, not even any recruitment which aimed at a permanent existence. Its participants did not separate their personal goals from the general goals of the movement. They were independent individuals who had come together for a struggle on a determined basis at a precise moment; and who once again became independent after the struggle had ended.[53]

Viénet, *Enragés and Situationists*, p. 105.

128

After a brief period in hiding, members of the SI left Paris and reformed
in Brussels. Here they set about telling their side of the story by quickly
producing the book, *Enragés et situationnistes dans le mouvement des
occupations* (*Enragés and Situationists in the Occupation Movement*).
The publisher, Gallimard, had the book quickly typeset and printed and
in the bookshops by 28 October 1968. Although credited solely to Viénet
the book was actually a collective effort, on the part of Debord, Becker-Ho,
Vaneigem, Khayati and Riesel. Here, one can find the SI's case for itself as
the precursor and exemplary theorists of the recent explosion:

The critical theory elaborated and publicised by
the Situationist International readily affirmed,
as the precondition of any revolutionary programme,
that the proletariat had not been abolished;
that capitalism was continuing to develop its own
alienations: and that this antagonism existed over
the entire surface of the planet.[54]

Viénet, *Enragés and Situationists*, p. 11.

They argued that the events of May '68 were much more wide-ranging and
significant than their disparaging description as "student revolt" would allow.
Unlike other uprisings these events were not the result of an economic crisis
but the cause of one. Only the SI predicted such a turn of events, asserting
that modern capitalism meant the proletarianisation of an increasing section
of the population. But, as the power of commodities came to dominate our
lives, it produced "an extension and deepening of the forces that negate it".[55]

Viénet, *Enragés and Situationists*, p. 71.

As for the success or failure of the events of May '68, opinion is
divided. According to the SI's own demands for a total revolution, May '68
can only be classed as an equally total failure. With the landslide election
victory of de Gaulle in June, the best, politically, that could be said for May
'68 was that it created the much-needed impetus for the modernisation
of the French education system and the overhaul of its industrial relations.[56]
Autocratic and strictly hierarchical company structures were slowly
restructured, but in terms of efficiency and productivity rather than social
justice. For the members of the SI the aftermath of May '68 must have been

De Gaulle stayed in power for just one year, up
to his resignation in April 1969. He
was succeeded by Georges Pompidou.

deeply depressing and characterised by a sense of crushing anti-climax. The next few months revealed the group's increasingly desperate attempts to rescue some kind of victory from this apparent defeat. In September 1969 they announced that May '68 was the greatest revolutionary moment in French history since the Paris Commune, listing amongst its achievements the first and largest wildcat general strike to take place in an advanced industrial country, the first steps towards direct democracy through the emergence of the occupations movement, the near total suspension of state control for almost two weeks, and finally, the verification of the SI's own revolutionary theory.[57] The other lessons of May '68 were more difficult to swallow. They showed that modern and advanced capitalist states had many ways to resist and repress such attacks on their sovereignty.

Anon, "The Beginning of an Era", in Knabb, 1981, p. 225. First published as "Le commencement d'une époque", *IS*, no. 12, September 1969, pp. 3-34.

The immediate task for the SI was to learn these lessons in a prodigious effort of self-historification, leading firstly to Viénet's book, and then to the extensive report "The Beginning of an Era" published in the twelfth and–unknown to them–last issue of *IS*. Also included in this issue was a collection of press reports that mentioned the SI in terms of varying degrees of inaccuracy.[58] The group knew that history would be its judge, but it also knew that, due to the nature of the spectacular media and its casual attitude to evidence, that judgement would not be definitive.

"Jugements choisis concernant l'IS et classés selon leur motivation dominante", *IS*, no. 12, September 1969, pp. 55-63.

As for the SI's judgement on May '68, the defeat of the movement and the preservation of the capitalist order were blamed squarely on the "politico-union bureaucratic machines" that defended the state of separation even more intensely than the police and army.[59] For Viénet, problems also lay in the movement's lack of an "exact and real" consciousness of the proletariat's historical role: "it is this inadequate relation between theory and practice which remains the fundamental trait of proletarian revolutions that fail", wrote Viénet. "Historical consciousness is an essential condition of social revolution."[60]

Knabb, *SI Anthology*, 1981, p. 225.

Viénet, *Enragés and Situationists*, 1992, p. 87.

# WILDCAT COMICS

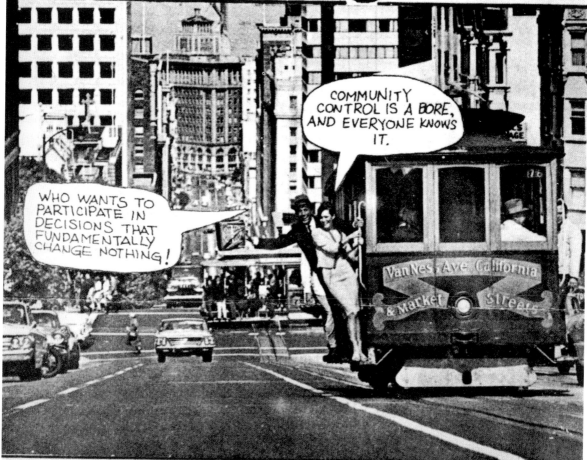

IN THE SOCIETY OF THE SPECTACLE A BUREAUCRATIC CLASS ACQUIRES POWER IN THE NAME OF RATIONALITY, WHILE THE BOURGEOISIE, CONFIDENT THAT ITS PROJECT, THE DEVELOPMENT OF THE COMMODITY ECONOMY, IS BEING MAINTAINED, RETIRES TO THE WINGS. THE UNIONS BECOME INSTRUMENTS OF THE RULING CLASS, PART OF THE BUREAUCRATIC MACHINE.

WHEN WILDCATS AND SABOTAGE REVEAL THE IRRATIONALITY OF THE BUREAUCRACY IN RELA-

TION TO HUMAN DESIRES, ANTI-BUREAUCRATS, POLITICIANS OF PARTICIPATION, ARRIVE TO JUSTIFY THE MAINTENANCE OF HIERARCHICAL POWER BY REDISCOVERING THE PROBLEM OF SURVIVAL. IN THE FACE OF FANTASTIC ACCUMULATION OF MATERIAL POSSIBILITIES, THEY ENCOURAGE THE PROLETARIAT TO BARGAIN FOR THE PIECEMEAL MANAGEMENT OF ITS SURVIVAL, SO THAT IT WON'T CONSTRUCT FOR ITSELF THE RICH LIFE NOW POSSIBLE.

THE SAN FRANCISCO CABLE CAR WILDCAT OF 1970 BEGAN WHEN A SPONTANEOUS DEMOCRATIC ASSEMBLY OF DRIVERS

Situationist comic, San Francisco, 1971.

# The Dissolution of the SI and its Aftermath

## 1969 and beyond

# The Veritable Split in the International

For the SI the immediate period after May '68 was one of intense reassessment and little activity occurred in the public realm beyond the publication of Viénet's book. One small incident that reportedly involved members of the SI took place in March 1969 when a local teacher, Pierre Lepetit, returned a remodelled statue of the utopian socialist Charles Fourier to a plinth on the Place Clichy. The original statue had been removed during the Nazi occupation. The second statue was quickly removed by the city authorities but not before it had provoked a heated debate in the local press. The SI later reported on the scandal in its journal, providing a photograph of the police guard around the statue before its removal and writing approvingly that "never before had *détournement* been at work in such a domain".[1]

Anon, "Le retour de Charles Fourier", *IS*, no. 12, September 1969, p. 97.

In June 1969 the one and only issue of the journal *Situationist International* was published by the American section of the SI. Based in New York the group was made up of Robert Chasse, Bruce Elwell, Jon Horelick, and Tony Verlaan. Their journal was closely followed in July by the publication of *Internazionale Situationista* by the Italian section under the guidance of Claudio Pavan, Paolo Salvadori, and Gianfranco Sanguinetti. Sanguinetti at the time was just 20 years old. Coming from a wealthy family, he also shared with Debord a love of revolutionary politics and a refined taste in food and wine.

Despite this international activity a deep malaise permeated through the central group based in Paris. Matters came to a head on 28 July when Debord announced that he would no longer edit future issues of *IS* and that he was handing over its management to the collective membership. Doubtlessly, like many editors he was repeatedly frustrated by the failure of writers to supply work that was on time and of sufficient quality. The next issue of the journal was to be under the control of the distinctly inexperienced and anti-intellectual grouping of Riesel, de Beaulieu, Sébastiani and Viénet, all noted for their bravery in moments of direct action but with little practice or talent for working with the written word. Inevitably, the team fared badly and, according to Debord, failed after more than a year to write even 15 lines of usable text: "Not that their writings were ever rejected by others; quite simply, they were not able to write anything which satisfied themselves. And on this point one must recognise that they

Debord, Guy and Gianfranco Sanguinetti, *The Veritable Split in the International: Public Circular of the Situationist International*, London: Chronos, 1990, p. 85. Translated by Lucy Forsyth and Michel Prigent from *La Véritable scission dans l'Internationale*, Paris: Éditions Champ Libre, 1972.

showed they were lucid."[2] Debord perceived many more examples of ineptitude and complacency and linked them to the increasing fame of the SI after May '68. The group's growing number of acolytes and fans–known condescendingly as "pro-Situs"–had begun to infiltrate and adversely effect its operations.

The final bumper issue of *IS* edited by Debord came out in September 1969, just in time for the SI's eighth conference in the Giudecca quarter of Venice. It was a particularly well-attended conference, perhaps too well-attended for Debord's taste, with many observers coming under suspicion of being police informers. The main topic of conversation was the "Provisional Statutes of the SI" which stated the group's constitution as an association of individuals, based on an equality of capabilities. It also defined the responsibilities of the national sections and set out the voting procedures for meetings. The question of discipline was uppermost on the agenda and the group advocated more regular meetings (every 15 days), sanctions against lateness and the refusal of any excuses of prior engagements–the SI, in all instances, had to be its members' primary concern. During the conference, Mustapha Khayati, author of *On the Poverty of Student Life* and, at the time, Debord's closest ally, handed in his resignation. He had recently joined the Popular Democratic Front for the Liberation of Palestine and no member of the SI was allowed to be part of another group.

After the conference, the new decade started with the exclusion of Robert Chasse and Bruce Elwell of the American section, followed closely

After their exclusion Chasse and Elwell produced a critical history of their involvement with the SI. See Robert Chasse and Bruce Elwell, *A Field Study in the Dwindling Force of Cognition, Where it is Least Expected: A Critique of the Situationist International as a Revolutionary Organization*, New York: Chasse and Elwell, 1970.

by the exclusion of Claudio Pavan and Eduardo Rothe of the Italian section.[3] More resignations and exclusions culminated in the exclusion of François de Beaulieu for "silliness and lack of dignity" and Patrick Cheval "because he had, after a drinking bout borne worse than the others, attempted

Debord and Sanguinetti, *The Veritable Split*, 1990, p. 87.

to defenestrate Sébastiani".[4] Debord supported this radical downsizing of the SI and positively helped it along with the circulation in November of a "Declaration", signed also by Riesel and Viénet, of the formation of a tendency within the SI. The Declaration expressed their frustration at the "inactivity and inability" of the other members: "This shameful silence is going to stop immediately because *we demand,* in the name of the rights and duties given to us by the SI's past and present, that each member

Debord, Riesel, and Viénet, "Declaration", in Knabb, *SI Anthology*, 1981, p. 367.

accept his responsibilities right now."[5]

Three days later Vaneigem announced his resignation. In his letter he criticised the "little penetration of Situationist theory into the workers' milieu and of the little workers' penetration into the Situationist milieu" describing this situation as the "the pretext for the false good consciousness

Vaneigem, Raoul, "Letter of Resignation", in Debord and Sanguinetti, *The Veritable Split*, 1990, p. 123.

of our failure".[6] Soon to follow Vaneigem were Horelick, Verlaan, Christian Sébastiani, and Viénet, who resigned for "personal convenience" and Riesel,

Debord, Guy, "Notes To Serve Towards The History of the SI From 1969-1971", in Debord and Sanguinetti, *The Veritable Split*, pp. 93-4. Viénet went on to produce a series of *détourned* Kung-Fu movies, the most famous of which he made with Gerard Cohen, entitled *La Dialectique peut-elle casser des briques*, 1973, also known as *Can Dialectics Break Bricks?* The film's subtitles bear little resemblance to the original dialogue and the story has been transformed into a battle between workers and capitalists.

excluded for "unscrupulous ambition".[7] The SI was thus reduced to just three active members: Debord, Sanguinetti and the now even more marginalized, JV Martin in Randers. The inevitable public announcement of the end of the SI came with the publication in April 1972 of Debord and Sanguinetti's *La Véritable scission dans l'Internationale* (*The Veritable Split in the International*).

The central section, "Theses on the SI and its Time", highlighted the many dangers threatening society including environmental issues relating to pollution, nuclear waste, and intensive farming techniques, and psychological strains manifested in the rising number of mental disorders and suicides. Debord also "explained", through a quotation from Hegel's *Phenomenology of Spirit*, the strategy behind the announcement of the tendency in November 1970:

One party proves itself to be victorious by breaking up into two parties; for in so doing, it shows that it contains within itself the principle it is attacking, and thus has rid itself of the one-sidedness in which it previously appeared. The interest which was divided between itself and the other party now falls entirely within itself, and the other party is forgotten, because the interest finds within itself the antithesis which occupies its attention. At the same time, however, it has been raised into the higher victorious element in which it exhibits itself in a clarified form. So that the schism that arises in one of the parties and seems to be a misfortune,

Debord and Sanguinetti, *The Veritable Split*, 1990, p. 9.

demonstrates rather that party's good fortune.[8]

The *Veritable Split* also acknowledged that the SI had outlived its purpose, and its growing reputation was beginning to handicap its operations. The intention now was to become *"even more inaccessible*, even more clandestine. The more our theses become famous, the more we will ourselves be obscure."[9] New forms of expression would need to emerge, new forms more appropriate to a new epoch. However, amongst the many questions the "comfortable spectators" of the SI would never have answered, alas, was "which metallic colour" had been chosen for the cover of the next issue of *IS*.[10]

Debord and Sanguinetti, *The Veritable Split*, 1990, p. 76.

Debord and Sanguinetti, *The Veritable Split*, p. 90.

## The Films of Guy Debord

On 5 August 1972 Debord married Alice Becker-Ho. The wedding ceremony did not necessarily represent any respect for the institution of marriage but, as Becker-Ho explained, "it was simply a way of preserving what Guy, we, had if times were tough".[11] In 1975 they bought a house in the small hamlet of Champot in the Auvergne. Over the coming years they would spend more time there, with summers often spent in Arles in Provence. Debord also regularly visited Florence, often in the company of Sanguinetti. Speculation circulated that he helped Sanguinetti produce a short book under the pseudonym of Censor, *Rapporto veridico sulle ultime opportunita di salvare il capitalismo in Italia* (*True Report on the Last Chance to Save Capitalism in Italy*).[12] The book was written in a conservative style, from the perspective of a bourgeois and well-read Christian Democrat, drawing on the work of Shakespeare, Nietzsche and Tocqueville. It presented a critique of contemporary Italian politics with some suggestions for undermining the influence of the Italian Communist party. Sanguinetti sent the book to the key opinion formers of the country and articles soon appeared in the press speculating on the identity of its author and the source of his apparently inside information.

Hussey, *The Game of War*, 2001, p. 282.

Censor (Gianfranco Sanguinetti), *Rapporto veridico sulle ultime possibilità di salvare il capitalismo in Italia*, Milan: Ugo Mursia, 1975. Debord later translated the text and published it as *Véridique rapport sur les dernières chances de sauver le capitalisme en Italie*, Paris: Éditions Champ Libre, 1976.

Debord finally split with Sanguinetti on the publication of the latter's *Del terrorismo e dello stato: la teoria e la practica del terrorismo per la prima volta divulgata* (*On Terrorism and the State: The Theory and Practice of Terrorism Divulged for the First Time*).[13] It was the book's subtitle that annoyed Debord, as it made no acknowledgement of his own recently published assessment of terrorism.[14] Both authors agreed, however, that

Sanguinetti, Gianfranco, *Del terrorismo e dello stato: la teoria e la practica del terrorismo per la prima volta divulgata*, Milan, 1979.

Debord, Guy, *Préface à la quatrième édition italienne de 'la société du spectacle'*, Paris: Éditions Champ Libre, 1979.

terrorist groups such as the Red Brigade were useful to the state because they justified ever-greater forms of repression, more intrusive and pervasive surveillance and state-sanctioned terrorism.

Away from these debates Debord's attention was taken up with filmmaking projects, all financed by his new friend, the film producer Gérard Lebovici. The two had first met in 1971 when Lebovici, through his publishing house Champ Libre, took over the publication of *The Society of the Spectacle* after Buchet had opportunistically added the subtitle *Situationist Theory* to the book without Debord's permission. At this time, Lebovici was a wealthy and successful entrepreneur in the French film world, running an agency that included on its books such illustrious clients as Jean-Paul Belmondo, Gérard Depardieu and Catherine Deneuve. During and after the May '68 events Lebovici developed a taste for the radical milieu and set up Champ Libre (Free Field) to spread the revolutionary word. Debord soon found himself a welcome if irregular visitor to the offices of Champ Libre on the Rue de la Montagne-Sainte-Geneviève (fittingly just a paving stone's throw away from the former headquarters of the Lettriste International).

Although rarely shown in the cinema, Debord's films have been widely circulated in script form for many years. His first three films were collected in the book *Contre le cinema,* published in 1964 with the extensive help of Asger Jorn.[15] In 1978 Champ Libre published Debord's *Oeuvres cinématographiques complètes: 1952-1978*, a collection of all his film scripts.[16] Significantly, Debord often described himself not as a writer of political

Debord, Guy, *Contre le cinéma*. Aarhus: Scandinave de vandalisme comperê, 1964.

Debord, Guy, *Oeuvres cinématographiques complètes: 1952-1978*, Paris: Éditions Champ Libre, 1978.

theory but as a filmmaker. For a time he even considered the film industry as a viable means of the Situationists making a living for themselves. In 1970 he wrote:

Each film could give one or two Situationists working as assistants the opportunity to master their own style in this language; and the inevitable success of our works would also provide the economic base for the future production of these comrades. *The*

Debord quoted in: Thomas Y. Levin, "Dismantling the Spectacle: The Cinema of Guy Debord", in McDonough, *Guy Debord*, 2002, p. 333.

*expansion of our audience is of decisive importance.* [17]

As already discussed, Debord's first phase of activity in cinema ended in 1961 with *Critique of Separation*. Twelve years and the whole history of the SI passed before Debord's next film, *La Société du spectacle* (*The Society of the Spectacle*), appeared on screen. Made in 1973 and released on 1 May 1974, Debord first announced his intention to film his book in the September 1969 issue of *IS*. But it was not until Debord met and befriended Lebovici that production of the film became a real possibility. Under the auspices of Lebovici's newly formed Simar Films, Debord received a generous advance of 300,000 francs and a royalty of 20 per

Hussey, *The Game of War*, 2001, p. 285.

cent of takings. [18] The contract he signed also provided an extravagant amount of artistic licence:

It is understood that the filmmaker will carry out his work in complete freedom, without any control or supervision whatsoever, and without even being obliged to pay the slightest attention to any comment that the producer might make regarding any aspect of the content or of the cinematic form

Debord, *Complete Cinematic Works*, 2003, p. 222.

that the filmmaker feels appropriate for his film. [19]

Although directed by Debord the film benefited from the assistance of the editor, Martine Barraqué, who located and copied the films needed for *détournement*. These included soft porn and advertising images of women,

scenes from war movies, news footage of riots and political speeches plus excerpts from classic films such as *Battleship Potemkin*, *October*, *Rio Grande* and *Johnny Guitar*. In addition to this new visual material the film differed greatly from the book with only about half of the original theses being used and many new passages of text appearing, some by Debord and some by Clausewitz, Marx and Machiavelli. Thus the film re-presented the central themes of the book, but in necessarily cinematic terms. Typically ostentatious, Debord advertised the film in the following terms: "Until now it has generally been assumed that film is a completely unsuitable medium for presenting revolutionary theory. This view was mistaken."[20]

Debord, *Complete Cinematic Works*, 2003, p. 220.

Debord's film paid particular attention to the phenomenon of celebrity as a key factor in our fascination with cinema. Alongside footage of the Beatles arriving at an airport and being welcomed by screaming and fainting teenage fans, Debord read in his emotionless monotone:

By concentrating in himself or herself the image of a popular role, the celebrity, spectacular representation of a living human being, concentrates this banality. The condition of the "Star" is the specialisation of the APPARENTLY LIVED; the object of identification with shallow apparent life, which must compensate for the fragments of actually lived productive specialisations. Celebrities exist in order to represent various types of life-styles and styles of comprehending society, free to express themselves GLOBALLY.[21]

Debord, *Society of the Spectacle and Other Films*, 1992, p. 80.

Although Debord's films were ostensibly films without stars this did not preclude their director deriving notoriety from their production. Although the distribution of *The Society of the Spectacle* was extremely limited the press coverage was substantial and often hostile. So numerous and unreceptive in fact that Debord was prompted to respond. Surprisingly, and uniquely perhaps in the history of cinema, his response took the form of another film.

He named this film, much to the dismay of cinema sign writers everywhere, as *Réfutation de tous les jugements, tant élogieux qu'hostiles, qui ont été jusqu'ici portés sur le film 'La société du spectacle'*, 1975, which translates as "Refutation of all judgements, whether in praise or hostile, which have been made up until now on the film *The Society of the Spectacle*".

Assisted once more by Barraqué, *Réfutation* borrows excerpts from television commercials, from coverage of the Olympic games in Munich and from news footage of the ongoing workers' uprising in Portugal. Debord's disdainful opening quotation comes from Chateaubriand: "There are times when one must be economical in one's expenditure of contempt, because of the large number of those in need of it." The film then proceeds to critique the "professional agents of falsification" describing their inability to pass comment on a film they will never understand, because the difficulty lies not in the film "but in their servile minds". *Réfutation* ends with Debord observing that while film critics might denounce his revolutionary politics as bad and leftwing critics might denounce his film as bad, he, as both a revolutionary and a filmmaker, asserts that "their shared bitterness stems from the fact that the film in question is a precise critique of the society they do not know how to combat; and the first example of a kind of film they do not know how to make".

Three years later, in 1978, Debord made what he declared to be his last film, *In girum imus nocte et consumimur igni*. The film was shot in black and white and lasted just over 100 minutes.[22] Its title came from a Latin palindrome meaning "We turn in the night, consumed by fire".[23] This last film carried echoes of earlier films, *On the Passage* and *Critique of Separation*, not least because André Mrugalski was once again employed as cameraman. The subject was also familiar: the life and times of the SI and its key theorist, Guy Debord, both represented partly through the themes of water (the passage of time) and fire (the flashpoint of revolution). The film opens with a face-on shot of a movie audience staring at the screen/camera. Over the soundtrack Debord insults his audience as "mystified ignoramuses who think they're educated" and as "zombies with the delusion that their votes mean something". He also denigrates cinema-going in general as serving no other purpose than "to while away an hour of boredom with a reflection of that

It took three years before it was finally shown at the Cinema Quintette Pathé on 6 May 1981, and on Canal 68, a pirate television channel, on the nights of 3 and 4 June 1981.

Debord, 2003, *Complete Cinematic Works*, p. 166. The author of the palindrome is generally thought to be Sidonius Apollinaris, a fifth century poet and bishop of Clermont.

same boredom". Of his own technique of *détournement* he declares: "I pride myself on having made a film out of whatever rubbish was at hand; and I find it amusing that people will complain about it who have allowed their entire lives to be dominated by every kind of rubbish."

A sub-theme of the film is the general decay of society, represented nostalgically in the destruction of Paris through crass redevelopment and increasing pollution. The film takes us back to the golden age of the 1950s, to the bars and cafes of Saint-Germain-des-Prés, where the slogan was "Nothing is true, everything is permitted". Quoting from his first film the screen at one point becomes completely white and Debord intones: "Like lost children we live our unfinished adventures." A series of clips from Michael Curtiz's 1936 film *The Charge of the Light Brigade* is then used to represent the 12 years of the SI's efforts to destabilise an entire society: "Classes and specialisations, work and entertainment, commodities and urbanism, ideology and the state– we showed that it all needed to be scrapped." Debord then explains his current state of self-enforced obscurity as the only way to avoid the compromises of fame and celebrity. The film ends with Debord celebrating the coming end of civilisation with the image of a ship about to capsize and sink. The closing subtitle commands: "To be gone through again from the beginning." Some years later, Debord explained what he meant by these final words:

First of all it means that the film, whose title is a palindrome, warrants immediately being seen again in order to achieve its fullest despair-producing effect–when you know how it ends, you will have a better idea of how to make sense of the beginning. It also means that everything will have to be recommenced–the actions evoked as well as the comments on them. Finally, it means that everything must be reconsidered from the beginning, corrected, and perhaps blamed, in order to eventually achieve more favourable results.[24]

Debord, *Complete Cinematic Works*, 2003, p. 241.

Despite Debord's high opinion of his own films he still found it very difficult to convince cinema managers it was worth their while to show them. This situation did not change until, in an extravagant gesture, Lebovici purchased a small cinema near the Sorbonne, the Studio Cujas, and showed Debord's films exclusively from October 1983 to April 1984. As another example of Lebovici's largesse Debord signed a contract with Lebovici to make a film about Spain. His salary was very generous, being 10,000 francs per month plus 400 francs per week living expenses.[25] Any chance of the project reaching completion ended, however, on 7 March 1984, when Lebovici's body was found in an underground car park, at the wheel of his Renault, with four bullet wounds in his head from a .22 calibre rifle. His killers were never identified. Debord, saddened by the murder of his friend and outraged by the press coverage of the case (and some journalists' libellous insinuations about his alleged involvement), withdrew all his films from circulation.[26]

For the next few years Debord turned his back on films and concentrated on various writing projects. The most significant of these was his *Panegyric*, its title deriving from the Greek word for a text praising an individual or institution. The irony here was that Debord bestowed this honour upon himself. His intention was clearly to set his affairs in order for posterity and the style he chose for this task drew on the writings of the seventeenth century Roman Catholic Bishop, Jacques-Bénigne Bossuet. From 1992 onwards Gallimard, the most venerable publishing house in France, began a project to reissue Debord's major works, and in the process cemented his status as a respected man of French letters. Debord's final book, *"Cette mauvaise réputation..."*(*"This Bad Reputation..."*), was published in 1993.[27]

By this stage Debord knew his time was running out. In the fall of 1990 he was diagnosed as suffering from peripheral neuritis, an incurable disease associated with alcoholism. Debord was under no illusions about his condition and its prognosis: "As with all incurable illness, one wins a lot by not seeking to, nor accepting to cure oneself. It's the opposite of an illness that can be contracted by a regrettable lack of prudence. On the contrary, it requires the loyal obstinacy of an entire life."[28] Debord shot himself in the heart on 30 November 1994. After his cremation on the 5 December his ashes were taken to Paris and cast into the Seine from the Square du Vert Galant, the prow of the Île du Cité.[29]

Bracken, *Guy Debord: Revolutionary*, Venice, CA: Feral House, 1997, p. 209. The information is taken from Guy Debord, *Des Contrats*, Cognac: Le temps qu'il fait, 1995.

It was not until the Venice Film Festival of 2001, and after Debord's suicide in 1994, that his widow Alice withdrew this ban. A set of English subtitled versions, based on Knabb's translation, is promised for release soon. The "Programme Guy Debord" played for the last time at Studio Cujas on 17 April 1984. For more on the assassination of Lebovici see Guy Debord, *Considération sur l'assassinat de Gérard Lebovici*, Paris: Éditions Gérard Lebovici, 1985. Translated by Robert Greene as *Considerations on the Assassination of Gérard Lebovici*, Los Angeles, CA: TamTam Books, 2001.

Debord, Guy, *"Cette mauvaise réputation ..."*, Paris: Gallimard, 1993.

Debord in a letter to the filmmaker Brigitte Cornand just before his suicide. Quoted in Bracken, *Guy Debord: Revolutionary*, 1997, p. 234.

A few weeks later a film made as a collaboration between Debord and Brigitte Cornand, *Guy Debord, son art et son temps* (*Guy Debord, his art, his time*) was shown on Canal Plus on 9 January 1995.

# History and Legacy

Even the most cursory examination of the SI's publications will reveal its fastidious chronicling of its own spectacular reflection in the mass media. Debord's films and books such as *Considerations on the Assassination of Gérard Lebovici* show him to be a keen reader of newspapers and his own reviews. For all his disdain for journalists and the mass media in general he still recognised publicity as a particular theatre of war that was eminently susceptible to contestation and distortion. The representation of the SI in history and within the legitimating institutions of art galleries and museums was not to be left to amateurs. To this end the SI developed both an archival strategy and what would now be recognised as a very successful media strategy–stay relatively obscure, spread rumours, drop key references, vastly exaggerate your strength, be extreme, and create scandal. The SI realised the processes of history to be inevitable and to ensure the survival of its version of events, the members would have to become their own historians. This process of self-historification began long before the SI officially disbanded in 1972. It included the sending of papers and publications to the archives at the Silkeborg Museum in Denmark and continued with the depositing of documents with the Institute of Social History in Amsterdam. Also as part of this plan, Debord saw through the publication of *L'Internationale situationniste: chronologie, bibliographie, protagonistes (avec un index des noms insultés)* in 1972 and the facsimile reprint of *Internationale situationniste* in 1975.[30] *The Veritable Split* contained a self-serving history lesson–"Notes To Serve Towards the History of the SI from 1969-1971"–followed, under the auspices of Champ Libre and its successor Éditions Gérard Lebovici, by other historically relevant publications such as the 1985 reprint of *Potlatch*. Perhaps the prime example of this tendency was Jean-François Martos's official history of the group, *Histoire de l'Internationale situationniste (History of the Situationist International)*, written under Debord's close supervision and published in 1989.[31] These publications now form the foundation of a still-burgeoning SI publishing industry.

Despite his vigilance Debord's control of the SI's history was far from total. Pro-Situ groups continued to appear and disappear after the SI's demise and each contributed to the dissemination of facts and fiction about

Raspaud, Jean-Jacques and Jean-Pierre Voyer, *L'Internationale situationniste: chronologie, bibliographie, protagonistes (avec un index des noms insultés)*, Paris: Éditions Champ Libre, 1972 and *Internationale situationniste 1958-1969*, Paris: Éditions Champ Libre, 1975.

Martos, Jean-François, *Histoire de l'Internationale situationniste*, Paris: Éditions Gérard Lebovici, 1989.

Poster announcing Ken Knabb's translation of Jean-Pierre Voyer's text "Reich, mode d'emploi" ("Reich: How To Use"), June 1973.

the group. British pro-Situs included the individuals and groups Combustion, King Mob, Pleasure Tendency, Blob, Omphalos, Chronos, Suburban Press, and Spectacular Times. Meanwhile in America the pro-Situ scene included Ken Knabb's Bureau of Public Secrets, Contradiction, Negation, Diversion, Point-Blank!, For Ourselves, Collective Inventions, Create Situations and the magazines *Not Bored* and *Processed World*. It was these groups that contributed most to establishing the SI's cult status in the 1970s and 1980s.

Few of these groups, however, managed to sustain an active level of engagement for very long. Many were also far from being slavish followers of the SI and acknowledged influences from a wide range of other ideologies, such as ultra-leftism, anarchism and libertarianism. The groups also tended to be vehemently antagonistic towards each other, often comically so, and this often resulted in periodic outbreaks of feuding within the milieu.

Logo for the New York Psychogeographical Association.

One group that did produce useful work was the reformed London Psychogeographical Association (LPA), revived in August 1992 and inaugurated with a cycle trip to the cave at Roisia's Cross, Royston, timed exactly to concur with the conjunction of Venus and Jupiter.[32] Over the next few years the group translated into English the Situationist work of Asger Jorn and revealed the strong connections between the SI and older millennial traditions.[33] The LPA's translation of Jorn's *Open Creation and its Enemies* also revealed his fascination with mathematics particularly in the area of topology (later associated with chaos theory). For the translator, Fabian Tompsett,

London Psychogeographical Association and the Archaeogeodetic Association, *The Great Conjunction: The Symbols of a College, the Death of a King and the Maze on the Hill*, London: Unpopular Books, 1992.

It should be remembered that one of Debord's favourite books was Norman Cohn's *The Pursuit of the Millennium*, an account of revolutionary millenarians and mystical anarchists of the Middle Ages and that Raoul Vaneigem wrote a book on *The Movement of the Free Spirit* one of the medieval cults examined by Cohn. The LPA believed that it is through making such connections that the spectacle is contested by an equally strong, but much older, counter-myth.

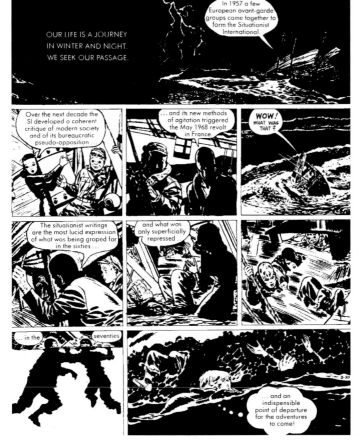

Bureau of Public Secrets, December 1981.

the text suggested that to understand the origins of the Situationist project we should return to 1895 when scientist and philosopher Henri Poincaré published his theories on the methods of topology, *Analysis situs* (usually translated as "positional analysis").[34]

Jorn, Asger, *Open Creation and its Enemies*, London: Unpopular Books, 1994.

Beyond this 'underground' milieu the SI's high profile within the contemporary mainstream can be attributed to one particularly unlikely factor, namely the usage of Situationist tactics by those associated with the punk rock band, the Sex Pistols. To examine these claims we need to go back to July 1966 and the publication in London of *Heatwave*, an underground magazine edited by Charles Radcliffe and described in its own pages as "a wild, experimental libertarian-socialist journal". For the second issue, published in September, Radcliffe was joined by Christopher Gray as co-editor. Both Gray and Radcliffe, along with Timothy Clark and Donald Nicholson-Smith, were then recruited by the SI to form its British section. We know this chiefly because they were all excluded on the 21 December 1967 (Radcliffe slightly earlier, in November). The reason for their exclusion was their fraternisation with an American named Ben Morea and a group calling itself variously Black Mask and the Motherfuckers and Up Against the Wall Motherfucker. Those connected with Black Mask included Ron Hahne, Tony Verlaan, Dan Georgiakas and the UK-based brothers Dave and Stuart Wise.[35]

Hahne, Ron and Ben Morea, *Black Mask and the Motherfuckers: The Incomplete Works of Ron Hahne, Ben Morea and the Black Mask Group*, London: Unpopular Books and Sabotage Editions, 1993.

After his expulsion from the SI, Gray joined forces with the Wise brothers and formed King Mob (a name adopted from graffiti painted on the wall of Newgate Prison during the Gordon Riots of 1780). King Mob's main source of inspiration was not the intense theorising of the SI but the 'freak' scene of 1960s counter-culture in general, and Black Mask in particular. One of the group's actions consisted of smashing up a Wimpy bar in protest against its interior decoration. Another, and one in which a certain Malcolm McLaren claims to have participated, involved the King Mob activists dressing up in Father Christmas outfits and storming into the toy department at Selfridges and gaily distributing the toys to confused children. King Mob also produced a flyer celebrating Valerie Solanas's shooting of Andy Warhol: "The death of art spells the murder of artists. The real anti-artist appears." Alongside Warhol on its 'hit-list' were Yoko Ono, Richard Hamilton and David Hockney.

At the time of his involvement with King Mob, McLaren was an art student studying at Croydon Art College. Here he befriended Jamie Reid and both became immersed in the counter-cultural radicalism of the times, culminating in a sit-in at Croydon in 1968. Fred Vermorel, a friend of McLaren's, was studying at the Sorbonne during the May '68 events, and on his return to London introduced him to Situationist literature.[36] McLaren, Vermorel and Reid then became aware of the King Mob group and started participating in their demonstrations. In 1970 Reid, along with Jeremy Brook and Nigel Edwards, set up the community magazine and print workshop *Suburban Press*. The magazine often carried snippets of Situationist texts plus Reid's graphic designs, many of which he would later reuse for Sex Pistols packaging. For example, Reid's *The Nice Drawing*, 1969, with its colour supplement happy family photograph *détourned* by the addition of Letraset captions such as "NICE young man", "NICE people", made its way from *Suburban Press* to the book *Leaving the Twentieth Century* and then on to the back cover of the Sex Pistols' 1977 single "Holidays in the Sun".[37]

Despite such connections the links between the SI and punk have often been overstated.[38] Reid later admitted that the level of his engagement with Situationist texts was far from deep:

I was never involved with the Situationists to the fullest extent because I couldn't understand half of what they had written. I found Situationist texts to be full of jargon–almost victims of what they were trying to attack–and you had to be really well-educated to be able to understand them. I was trying to put over the waffle in a visual form; trying say, to summarise a whole chapter of a book in one image. There was a way in. I wasn't so much attracted to the Situationist theory as to how they approached media and politics. The slogans, for instance, were so much better than the texts.[39]

According to Fred Vermorel, *Fashion and Perversity: A Life of Vivienne Westwood and The Sixties Laid Bare*, London: Bloomsbury, 1997, pp. 173-8.

Edited by Christopher Gray, *Leaving the Twentieth Century* was the first book to provide an overview of Situationist texts in English. Christopher Gray ed., *Leaving the Twentieth Century: The Incomplete Work of the Situationist International*, London: Free Fall Publications, 1974.

For more on this subject see Stewart Home, *Cranked Up Really High*, Hove: Codex, 1995, especially the chapter "Blood Splattered with Guitars", pp. 19-30.

Reid, Jamie and Jon Savage, *Up They Rise: The Incomplete Works of Jamie Reid*, London: Faber & Faber, 1987, p. 38. During the 1990s Reid became increasingly embroiled in Celtic mythology and Druid symbolism. Reid's great uncle, George Watson MacGregor-Reid, was once head of the Druid Order. His travelling and evolving exhibition *Celtic Surveyor X: Slate* was shown at the Oriel Bangor, Wales, 5 April-14 May 1994.

McLaren's understanding of SI texts was similarly superficial, but in an equally productive sense: "I'd heard about the Situationists from the radical milieu of the time. You had to go up to Compendium Books. When you asked for the literature, you had to pass an eyeball test. Then you got these beautiful magazines with reflecting covers in various colours: gold, green, mauve. The text was in French: you tried to read it, but it was so difficult. Just when you were getting bored, there were always these wonderful pictures and they broke the whole thing up. They were what I bought them for: not the theory."[40] The lead singer of the Sex Pistols, Johnny Rotten, remained the most outspoken on the SI's alleged influence: "All that talk about the French Situationists being associated with punk is bollocks. It's nonsense! Now that really *is* coffee-table book stuff. The Paris riots and the Situationist movement

Savage, Jon, *England's Dreaming: Sex Pistols and Punk Rock*, London: Faber & Faber, 1991, p. 30.

Left:
Comic with passages from Ken Knabb's *The Joy of Revolution*, 1998, Bureau of Public Secrets.

Right:
Jamie Reid, *Nice Drawing*, 1973. Courtesy: Arcova Publishing.

Lydon, John, *Rotten: No Irish, No Blacks, No Dogs: The Authorised Autobiography*, London: Hodder & Stoughton, 1994, p. 3.

of the 1960s–it was all nonsense for arty French students."[41] Despite such

statements the attractive myth of the 'pop Situationists' shows no sign of

disappearing and references to the SI continue to permeate through popular

See the chapter "The Pop Situationists" in Simon Frith and Howard Horne, *Art into Pop*, London: Methuen, 1987, pp. 123-161. For its persistence see: Robert Garnett, "Too Low to be Low: Art Pop and the Sex Pistols", in Roger Sabin ed, *Punk Rock: So What? The Cultural Legacy of Punk*, London: Routledge, 1999, pp. 17-30.

culture.[42] For example, on Ian Brown's album *Unfinished Monkey Business*,

1997, you could listen to tracks inspired by Situationist slogans "Under the

Paving Stones: the Beach" and "Corpses in their Mouths" and in 1998 Radio

One DJ, John Peel, could be heard asking listeners to phone in if they knew

who Guy Debord was, because the next track was named after him (it was by

Rudolph Rocker).

The SI's media profile also benefited from a continuing nostalgia

for anything connected to May '68. This was particularly so during the

twentieth anniversary celebrations in 1988. However, the key factor in

establishing the SI's reputation was the large travelling retrospective

The exhibition was organised by Peter Wollen and Mark Francis, with Paul-Hervé Parsy, in consultation with Thomas Y Levin, Greil Marcus, and Elisabeth Sussman. A separate catalogue was produced for each show: Musée national d'art moderne, Centre Georges Pompidou, Paris, France, 21 February-9 April 1989; Institute of Contemporary Arts, London, England, 23 June-13 August 1989; Institute of Contemporary Arts, Boston, MA, 20 October 1989-7 January 1990.

exhibition of 1989, which visited Paris, London, and Boston.[43] The show's

curators found themselves in a difficult position: was the show meant to

be in the spirit of the SI–cue slogan t-shirts and pin-ball machines–or was

it meant to be a conventional historical retrospective, a survey show with

art on walls and documents in display cases? As is often the case they chose

to do a bit of both. Such shortcomings, however, did nothing to dampen the

significant amount of press coverage the show attracted. From that point

See the section "1989 Exhibition and Catalogue Reviews" in Simon Ford, *The Realization and Suppression of the Situationist International: An Annotated Bibliography, 1972-1992*, Edinburgh: AK Press, 1995, pp. 123-130.

onwards knowledge of the SI definitively outgrew its previous cult status.[44]

Concepts such as psychogeography, *dérive* and *détournement*, became part of

the common language of both critical and uncritical discourse, both within

For example the novelist and journalist Will Self currently has a regular column entitled "Psychogeography" in the daily British newspaper *The Independent*.

academia and the mass media.[45]

Left:
Booklet for the ICA
exhibition
The Situationist
International
1957-1972, 23 June-
13 August 1989.

Right:
Jamie Reid, *Never Mind
The Bollocks* (Album
Poster), Lithograph,
1977. Courtesy: Arcova
Publishing.

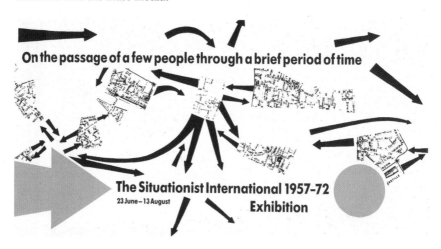

Sherrie Levine, *After Walker Evans*, no. 1, 3, 4, 5, 2, 6 (clockwise from top left), 1981. Courtesy: Paula Cooper Gallery, New York.

The travelling exhibition stressed the links between the SI and
other artists (Marcel Broodthaers, Mario Merz, Daniel Buren and Art &
Language etc.) who, the curators believed, were either influenced or produced
work analogous to the SI. Commentators also found echoes in the then
popular appropriationist strategies of American artists Barbara Kruger,
Richard Prince, and Sherrie Levine.[46] As a form of *détournement* these artists
re-contextualized pre-existing images, but as career artists they did little to
threaten either the institutional context or the commodity status of the work
of art. Such disparity of ambition continued to be the main problem when
Situationist ideas were used within an art world context. According to some,
however, it was the 'art dimension' that made the SI's politics "the deadly
weapon it was for a while".[47] This position though–of trying to save the SI for
art–must always come up against the SI's unequivocal disdain for both art and
artists and its institutional support structures. This disdain was explicit from
early texts such as "The Meaning of Decay in Art", where the SI write that

See Edward Ball, "The Beautiful Language of my Century: From the Situationists to the Simulationists", *Arts Magazine*, vol. 63, no. 5, January 1989, pp. 65-72.

Clark, T J and Donald Nicholson-Smith, "Why Art Can't Kill the Situationist International", in McDonough, *Guy Debord*, 2002, p. 29.

Poster, Aquarium Gallery, The S.I. & After: the timetable so far, August 2003.

Situations are conceived as the opposite of works of art, which are attempts at absolute valorisation and preservation of the present moment. ... Like the proletarians, theoretically, before the nation, the Situationists are encamped at the gates of culture. They do not want to establish themselves inside; they *decline* to inscribe themselves in modern art; they are the organisers of the absence of that aesthetic avant-garde that bourgeois critics are waiting for and which, forever disappointed, they are prepared to greet on the first occasion.[48]

Editorial, "The Meaning of Decay in Art", in McDonough, *Guy Debord*, 2002, pp. 85–93. Translated by John Shepley from *Internationale situationniste*, no. 3, December 1959, pp. 3–8.

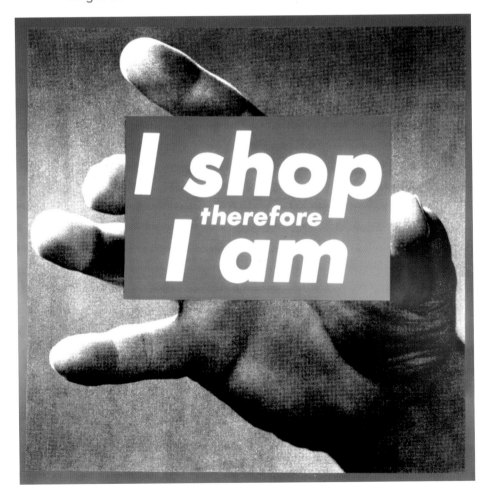

Barbara Kruger, *Untitled* (*I shop therefore I am*), 111" by 113", photographic silkscreen/vinyl, 1987, Courtesy: Mary Boone Gallery, New York.

Art, for Debord, decreased even further in importance as he increasingly took on the persona of a dedicated revolutionary. Despite Debord's claim in 1961 to be embarking on "a revolutionary critique of all art" and his work as a filmmaker, artistic problems rarely warranted a mention.[49]

Debord, Guy, "For a Revolutionary Judgment of Art", in Knabb, *SI Anthology*, 1981, p. 311.

The SI's often contradictory relationship with art was not its only inconsistency. There remains a huge question mark over the group's attitude to feminist issues and a lack of fit between its anti-hierarchical organisational programme (described once as a "Conspiracy of Equals") and its actual organisational self-limitation (i.e. it was exclusive and hierarchical and dominated by one man, Debord).[50] The exponents of post-structuralism have also questioned some of the group's founding precepts, such as its ability to recognise 'true' desires and its reliance on models of direct communication. As Sadie Plant observed, the SI's desire for "the end of all separation, mediation and alienation" is for many contemporary observers little more than "misguided dreams".[51]

"Conspiracy of Equals" comes from Anon, "The Countersituationist Campaign in Various Countries", in Knabb, *SI Anthology*, 1981, p. 113. First published in *IS*, no. 8, January 1963.

Plant, *The Most Radical Gesture*, 1992, p. 109.

Despite these criticisms the SI continues to attract followers. In Naomi Klein's best-selling, *No Logo*, the group gets a favourable mention as pioneers of 'culture jamming', a form of adbusting or *détournement* applied to the commercial landscape. According to Klein the band Negativland coined the term in 1984, but she is keen to also credit Debord and the SI, "the muses and theorists of the theatrical student uprising of Paris, May 1968".[52] While the adoption of SI techniques by anti-corporate activists may be welcome by some pro-Situs, parallel appropriation by the exponents of hip consumerism and lifestyle marketing, especially through the reuse of slogans such as "take your dreams for reality" were less well received. Such pseudo-liberationist exhortations are now a staple of the advertising industry, and even Debord's "never work" has become a rallying call for flexible knowledge workers.[53] In a telling inversion the Situationists in this context become the role model of the hedonistic, conspicuous consumer of contemporary city life, perfectly in tune with a culture that feeds on contradiction and contrast, that advertises through anti-adverts and that promotes art through anti-art. There should

Nature...

IT'LL GROW BACK

Adbusting by Abrupt, 1996.

Klein, Naomi, *No Logo*, London: Flamingo, 2001, p. 282.

On the importance of avant-gardist and bohemian non-conformity in the rise of post war consumerism see: Thomas Frank, *The Conquest of Cool: Business Culture, Counterculture, and the Rise of Hip Consumerism*, Chicago: University of Chicago Press, 1997.

be nothing surprising in this inversion. As Bertolt Brecht pointed out, "capitalism has the power instantly and continuously to transform into a drug the very venom that is spit in its face, and to revel in it".[54] The SI called this process 'co-option'–the means by which oppositional and counter-cultural tendencies are appropriated by commercial and bureaucratic interests and then re-presented as safe for mass consumption. During this process the marginal gets drawn into the centre and the experimental becomes conventional. What now could be the point of an avant-garde when, within the capitalist economy, transgression and shock were recognised as necessary stimulants towards increased consumption?

Cited in Paul Mann, *The Theory-Death of the Avant-Garde*, Bloomington: Indiana University Press, 1991, p. 86.

Barbara Kruger, *Untitled (Not stupid enough)*, 109" by 109", photographic silkscreen/vinyl, 1997. Courtesy: Mary Boone Gallery, New York.

By the time of Debord's suicide the SI had already established its place within the pantheon of the historical avant-garde. Some even argued that the SI represented the conclusive climax of that tradition. Peter Wollen, for example, believed that its dissolution in 1972 "brought to an end an epoch which began in Paris with the 'Futurist Manifesto' of 1909".[55] A self-reflexive understanding of its role within this tradition distinguished the SI, but it would never have recognised itself as its conclusion, or its end. Its key strategies focussed on avoiding definition, of strategic withdrawal, and, put simply, of 'never working' in this sense at least. The SI aimed to embody a form of artistic rebellion not recuperable in either history books or art works. In 1963 this was described as a new way of life: "there exist in several modern capitalist countries centres of non-artistic bohemianism united around the notion of the end of or the absence of art, a bohemianism that explicitly no longer envisages any artistic production whatsoever".[56] It is this sense of an alternative way of life that remains a key part of the SI's attraction today. To study and learn from the lessons of the SI is no idle pastime or exercise in passive contemplation. It is nothing if not a determined step towards the realisation of a future society where the SI's ideas about a useful life are no longer quite so exceptional.

Wollen, Peter, "Bitter Victory: The Art and Politics of the Situationist International", in Sussman, *On the Passage*, 1989, p. 27.

Anon, "Ideologies, Classes and the Domination of Nature", in Knabb, *SI Anthology*, 1981, p. 107. First published in *IS*, no. 8, January 1963.

Situationist documents exhibition at the Copenhagen Free University, 2003.

Chronology

**1946**

Isidore Isou forms the Lettriste movement with Gabriel Pomerand in Paris.

**1948**

November. Cobra formed.

**1950**

April. Lettristes disrupt Easter Mass at Notre-Dame in Paris.

**1951**

20 April. Guy Debord meets Isou and the other Lettristes at the Fourth Cannes
Film Festival.

October. Debord moves to Paris.

Cobra dissolved.

**1952**

June. Debord along with Serge Berna, Jean-Louis Brau, and Gil J Wolman, secretly
form the Lettriste International (LI) tendency.

30 June. First screening of Debord's film *Hurlements en faveur de Sade*.

29 October. LI's anti-Chaplin demonstration takes place at the Ritz Hotel, Paris.

7 December. LI founding congress in Aubervilliers, Paris.

First issue of *Internationale Lettriste*.

**1953**

October. Ivan Chtcheglov presents the essay "Formulary for a New Urbanism" to the LI.

Rumney starts the journal *Other Voices* in London.

Debord paints a slogan on a wall on the rue de Seine: *"Ne Travaillez Jamais!"*
("Never Work!").

International Movement for an Imaginist Bauhaus formed in Switzerland.

**1954**

22 June. First issue of *Potlatch*.

August. Debord and Michèle Bernstein marry.

**1956**

September. *First World Congress of Free Artists* at Alba, Italy.

Debord produces *Guide psychogéographique de Paris: discours sur les passions de
l'amour (Psychogeographical Map of Paris: discourse on the passions of love)*.

Wolman excluded from the LI.

February. *First Exhibition of Psychogeography*, Taptoe Gallery, Brussels.

May. Jorn and Debord collaborate on the book *Fin de Copenhague*.

The film *Hurlements en faveur de Sade(Howls for Sade)* is shown at the Institute
of Contemporary Art (ICA) in London.

June Debord writes *Rapport sur la construction des situations et sur les conditions de
l'organisation et de l'action de la tendance situationniste international (Report
on the Construction of Situations and on the Terms of Organization and Action
of the International Situationist Tendency)*.

27-28 July. Founding conference of the SI at Cosio d'Arroscia, Italy.

*Love on the Left Bank*, a book by Ed Van der Elsken.

Debord publishes the map *The Naked City: illustration de l'hypothèse des plaques
tournantes en psychogéographique (The Naked City: Illustration of the hypothesis
of geographic turntables)*.

1958

25-26 January. Second SI conference held in Paris. Walter Olmo, Piero Simondo and
Elena Verrone officially excluded.

March. Rumney excluded.

May. First exhibition of industrial paintings by Guiseppe Pinot-Gallizio at the Notizie
Gallery, Turin, Italy.

June. First issue of *Internationale situationniste*.

September. Jorn's first solo exhibition at the Van de Loo Gallery, Munich.
While there he recruits 'Gruppe Spur' to the SI cause.

December. Jorn and Debord collaborate on the book *Mémoires*.

December. Constant and Debord write the 11 point *Amsterdam Declaration*
on unitary urbanism

1959

February. Constant sets up the Bureau of Unitary Urbanism in Amsterdam.

17-30 April. Third SI conference held in Munich.

May. Pinot-Gallizio's *Caverna dell'anti-materia (Cavern of anti-matter)* exhibition
at Galerie René Drouin, Paris.

May. Jorn's *Modifications (peintures détournées)* (*Modifications* (détourned paintings)) exhibition at Galerie Rive Gauche, Paris.

Debord's film *Sur le passage de quelques personnes à travers une assez courte unité de temps* (*On the Passage of a Few people through a Rather Brief Moment in Time*).

**1960**

31 May. Pinot-Gallizio excluded.

June. Constant resigns.

August. First issue of *Spur*, the journal of the German section appears.

24-28 September. Fourth SI conference held at the British Sailors Society in London. During the conference, there is an SI evening at the ICA which ends with Debord insulting the audience and leading the Situationists out of the room.

Debord and Bernstein sign the *Declaration on the Right to Insubordination in the Algerian War*.

**1961**

11-13 April. Munich. Central committee meeting. Jorn resigns and Maurice Wyckaert is excluded.

August. Fifth SI conference held in Göteborg.

Film. Debord's *Critique de la séparation*.

**1962**

10-11 February. Central Council meeting of the SI. Leads to expulsion of the 'Spurists'.

March. Scission of the 'Nashists'.

June. Jorn's *Nouvelles défigurations* (*New Disfigurations*) exhibition at Galerie Rive Gauche, Paris.

12-15 November. Sixth SI conference held in Antwerp.

**1963**

22 June – 7 July. *Destruction of the RSG-6* takes place at the Exi Gallery, Odense, Denmark. Publication of *The Situationists and The New Forms of Actions in Politics or in Art*.

**1964**

Autumn. Exclusion of Alexander Trocchi.

3 September. Bernstein and Nash publish articles in the *Times Literary Supplement*.

Publication of Debord's *Contre le cinéma* (*Against Cinema*).

24 March. A group of pro-Situ students at the University of Strasbourg disrupt a lecture by Abraham Moles and the cybernetic sculptor Nicolas Schöffer.

July. Publication of *Adresse aux révolutiooaires d'Algérie et de tous les pays* (*Address to the Revolutionaries of Algeria and All Countries*).

December. Publication by the SI of *The Decline and Fall of the Spectacular Economy*, on the Watts riots in Los Angeles.

14 May. Pro-Situ students at the University of Strasbourg are elected to run the local students' union.

9-11 July. Seventh SI conference held in Paris.

November. Publication of *Le retour de la colonne Durruti* (*The Return of the Durutti Column*) and *De la misère en milieu étudiant* (*On the Poverty of Student Life*) in Strasbourg.

14 November. Publication of Debord's book *La Société du Spectacle* (*The Society of the Spectacle*).

30 November. Publication of Vaneigem's book *Traité de savoir-vivre à l'usage des jeunes générations* (*The Revolution of Everyday Life*).

21 December. TJ Clark, Donald Nicholson-Smith and Christopher Gray excluded. Charles Radcliffe resigns in November.

22 March. Occupation at Nanterre University by various leftist groups including the Enragés and a group led by Daniel Cohn-Bendit.

May. May '68 events in France.

30 May. Charles De Gaulle appears on French television and announces a general election.

30 June. Election victory of de Gaulle.

October. Publication of *Enragés et situationnistes dans le mouvement des occupations* (*Enragés and Situationists in the Occupations Movement*).

March. Members of the SI return a remodelled statue of the anarchist Charles Fourier
    to a plinth on the place Clichy, Paris.

June. American section publishes first issue of *Situationist International* in New York.

July. Italian section publishes first issue of *Internazionale Situationista* in Milan.

September. SI publish the last issue of *Internationale situationniste*.

26 September-1 October. Eighth SI conference in Venice. Mustapha Khayati resigns.

1970

11 November. Debord, René Riesel and René Viénet issue the *Declaration* proclaiming
    the creation of a tendency within the SI.

14 November. Raoul Vaneigem resigns.

1971

Debord befriends Gérard Lebovici.

1972

Jean-Jacques Raspaud and Jean-Pierre Voyer's *L'Internationale Situationniste:*
    *chronologie, bibliographie, protagonistes (avec un index des noms insultés),*
    (*The Situationist International: Chronology, Bibliography, Protagonists*
    (*With An Index of People Insulted*)), published by Champ Libre.

April. The end of the SI announced in Debord and Gianfranco Sanguinetti's *La Véritable*
    *scission dans l'Internationale* (*The Real Split in the International*).

5 August. Debord marries Alice Becker-Ho.

1973

1 May. Jorn dies of lung cancer.

1974

1 May. Release of Debord's film *La Société du spectacle*.

Publication of Chris Gray's *Leaving the Twentieth Century: The Incomplete Work*
    *of the Situationist International*.

1975

Publication of *Internationale situationniste 1958-1969* by Champ Libre.

Sanguinetti, using the pseudonym Censor, writes and publishes *Rapporto veridico*
    *sulle ultime possibilità di salvare il capitalismo in Italia* (*Veritable Report*
    *on the Last Chances to Save Capitalism in Italy*).

Release of Debord's film *Réfutation de tous les jugements, tant élogieux qu'hostiles, qui ont été jusqu'ici portés sur le film 'La société du spectacle'* (*Refutation of all judgements, whether for or against, concerning the film "The Society of the Spectacle"*).

1978

Completion of Debord's film *In girum imus nocte et consumimur igni*.

Debord's *Oeuvres cinématographiques complètes: 1952-1978* published by Champ Libre.

1979

Sanguinetti publishes *Del terrorismo e dello stato: la teoria e la practica del terrorismo per la prima volta divulgata* (*On Terrorism and the State: the theory and practice of terrorism, divulged for the first time*).

Debord publishes *Préface à la quatrième édition italienne de la société du spectacle*.

1981

Knabb publishes *Situationist International Anthology*.

6 May. Release of Debord's film *In girum imus nocte et consumimur igni*.

1983

October-April 1984. Debord's films shown exclusively at the Studio Cujas, Paris.

1984

7 March. Lebovici's murdered body discovered.

April. Debord withdraws all his films from circulation.

1985

Debord's *Considération sur l'assassinat de Gérard Lebovici* (*Considerations on the Assassination of Gérard Lebovici*) published.

1987

Debord and Becker-Ho's *Le "Jeu de la Guerre"* (*The "Game of War"*) published.

1988

Debord's *Commentaire sur la société du spectacle* (*Comments on the Society of the Spectacle*) published.

1989

21 February-9 April, SI retrospective exhibition at the Musée national d'art moderne, Centre Georges Pompidou, Paris.

23 June-13 August, SI retrospective at the ICA, London.

20 October-7 January 1990, SI retrospective at the Institute of Contemporary Arts (ICA), Boston, Massachusetts.

Jean-François Martos's *Histoire de l'Internationale situationniste* published.

Debord's *Panegyric, Volume 1* published.

1993

Debord's *"Cette mauvaise réputation ..."* (*"This bad reputation"*) published.

1994

30 November. Debord shoots himself in the heart.

1995

9 January. Transmission on Canal Plus of the film *Guy Debord, son art et son temps*.

# Further Information

## Public Collections

The most important public collection of SI material is to be found in the Silkeborg Museum. This collection was initially built up because of Asger Jorn's connection with the group. There are also many internal documents deposited by the SI in the Institute of Social History in Amsterdam. Other archives include the Bibliothèque de Documentation Internationale Contemporaine at Nanterre and the Musée national d'art moderne, Centre Georges Pompidou, Paris. The most substantial collection of SI and pro-Situ material in Britain is to be found at the National Art Library, Victoria and Albert Museum, London. There is also a collection 'Internationale Situationniste Ephemera, 1947-1975' (accession no. 980047) in the Special Collections at the Getty Research Institute for the History of Art and the Humanities.

## Internet Resources

Situationist International Online:
> http:// www.cddc.vt.edu/sionline

Infopool:
> http://www.infopool.org.uk

National Art Library Online Catalogue:
> http://www.vam.ac.uk/nal/index.html

Not Bored website:
> http://www.notbored.org

A Situationist Bibliography
> http://tallett.com/situ

Bureau of Public Secrets:
> http://www.bopsecrets.org

Debordiana:
> http://www.chez.com/debordiana

The Situationist International Text Library:
> http://library.nothingness.org/articles/SI/all/

## Primary Sources

Bernstein, Michèle, *Pinot-Gallizio*, Paris: Bibliothèque d'Alexandrie, 1960.

Bernstein, Michèle, *Tous les chevaux du roi*, Paris: Buchet-Chastel, 1960.

Bernstein, Michèle, *La Nuit*, Paris: Buchet-Chastel, 1961.

Chasse, Robert and Bruce Elwell, *A Field Study in the Dwindling Force of Cognition, Where it is Least Expected: A Critique of the Situationist International as a Revolutionary Organization*, New York: Chasse and Elwell, 1970

Constant, *New Babylon*, Den Haag: Gemeentemuseum, 1974.

Constant, *New Babylon: Art et Utopie, texts situationnistes*, Paris: Cercle d'Art, 2000.

Debord, Guy, and Asger Jorn, *Fin de Copenhague*, Copenhagen: Permild & Rosengreen, 1957. Facsimile edition published in 1985 by Éditions Allia.

Debord, Guy, and Asger Jorn, *Mémoires*, Paris: Internationale situationniste, 1959. A facsimile edition was published by Éditions Allia in 2004.

Debord, Guy, *Contre le cinema*, Aarhus: Scandinave de vandalisme comperé, 1964.

Debord, *La société du spectacle*, Paris: Buchet-Chastel, 1967. Translated by Donald Nicholson-Smith as *The Society of the Spectacle*, New York: Zone Books, 1994.

Debord, Guy and Gianfranco Sanguinetti, *La Véritable scission dans l'Internationale*, Paris: Éditions Champ Libre, 1972. Translated by Lucy Forsyth and Michel Prigent as *The Veritable Split in the International: Public Circular of the Situationist International*, London: Chronos, 1990.

Debord, Guy, "On Wild Architecture" in Jorn, Asger, *Le Jardin d'Albisola*, Turin: Edizioni d'arte Fratelli Pozzo, 1974.

Debord, Guy, *Oeuvres cinématographiques complètes: 1952-1978*. Paris: Éditions Champ Libre, 1978. Translated and edited by Ken Knabb as *Complete Cinematic Works: Scripts, Stills, Documents*, Edinburgh and Oakland, CA: AK Press, 2003. Selected films also translated by Richard Parry as; *Society of the Spectacle and Other Films*, London: Rebel Press, 1992; and translated by Lucy Forsyth as *In girum imus nocte et consumimur igni*, London: Pelagian Press, 1992.

Debord, Guy, *Préface à la quatrième édition italienne de 'la société du spectacle'*, Paris: Éditions Champ Libre, 1979. Translated by Michel Prigent and Lucy Forsyth as *Preface to the Fourth Italian Edition of 'The Society of the Spectacle'*, London: Chronos Publications, 1983.

Debord, Guy, *Ordures et décombres déballés à la sortie du film "in girum imus nocte et consumimur igni"*, Paris: Éditions Champ Libre 1982.

Debord, Guy, *Considération sur l'assassinat de Gérard Lebovici*, Paris: Éditions Gérard Lebovici, 1985. Translated by Robert Greene as *Considerations on the Assassination of Gérard Lebovici*, Los Angeles, CA: TamTam Books, 2001

Debord, Guy and Alice Becker-Ho, *Le 'Jeu de la guerre': relevé des positions successives de toutes les forces au cours d'une partie*, Paris: Éditions Gérard Lebovici, 1987.

Debord, Guy, *Commentaire sur la société du spectacle*, Paris: Éditions Champ Libre, 1988. Translated by Malcolm Imrie as *Comments on The Society of the Spectacle*, London: Verso, 1990.

Debord, Guy, *Panégyrique I*, Paris: Éditions Gérard Lebovici, 1989. Translated by James Brook as *Panegyric: Volume 1*, London: Verso, 1991.

Debord, Guy, *"Cette mauvaise réputation ... "*, Paris: Gallimard, 1993.

Debord, Guy, *Des Contrats*, Cognac: Le temps qu'il fait, 1995.

Debord, Guy ed., *Potlatch: 1954-57*. Paris: Gallimard, 1996. First published by Éditions Gérard Lebovici in 1985.

Debord, Guy, *Panégyrique 2*, Paris: Arthème Fayard, 1997.

Gruppe Spur, *Ein kultureller Putsch: Manifeste, Pamhplete und Provokationen der Gruppe SPUR*, Hamburg: Nautilus, 1991.

*Internationale situationniste 1958-1969*, Paris: Éditions Champ Libre, 1975.

Isou, Jean Isidore, *Introduction à une Nouvelle Poésie et une Nouvelle Musique*, Paris: Gallimard, 1947.

Isou, Jean Isidore, *Contre le cinéma situationniste, néo-nazi*, Paris: Librairie la Guide, 1979.

Jorn, Asger, *Open Creation and its Enemies with Originality and Magnitude (On the System of Isou)*, London: Unpopular Books, 1994. Translated by Fabian Tompsett.

Knabb, Ken ed., *Situationist International Anthology*, Berkeley: Bureau of Public Secrets, 1981.

Magnus, Carl et al, *Situationister i konsten*, Örkelljunga: Bauhaus situationiste, 1966.

Mension, Jean-Michel, *La Tribu*, Paris: Éditions Allia, 1998. Translated by Donald Nicholson-Smith as; *The Tribe*, London: Verso, 2002.

Nash, Jørgen, *Hanegal, gallisk poesiealbum*, Paris: Édition Internationale situationniste, 1961.

Rumney, Ralph, *Le Consul*, Paris: Éditions Alia, 1999. Translated by Malcolm Imrie as *The Consul*, London: Verso, 2002.

Sanguinetti, Gianfranco (Censor), *Rapporto veridico sulle ultime possibilità di salvare il capitalismo in Italia*, Milan: Ugo Mursia, 1975. Debord's translation published as *Véridique rapport sur les dernières chances de sauver le capitalisme en Italie*, Paris: Éditions Champ Libre, 1976.

Sanguinetti, Gianfranco, *Del terrorismo e dello stato: la teoria e la practica del terrorismo per la prima volta divulgata*, Milan, 1979. Translated by Lucy Forsyth and Michel Prigent from the 1980 French translation by Jean-François Martos as *On Terrorism and the State: The Theory and Practice of Terrorism Divulged for the First Time*, London: Chronos, 1982.

Situationist International and and the AFGES, *De la misère en milieu étudiant, considérée sous ses aspects économique, politique, psychologique, sexuel et notamment intellectuel et de quelques moyens pour y remédier*, Strasbourg: Association fédérative générale des étudiants de Strasbourg, 1966. The first English translation was published in London in 1967, translated by Donald Nicholson-Smith and TJ Clark and edited by Christopher Gray. A more recent English translation is: *On the Poverty of Student Life*, London: Dark Star Press and Rebel Press, 1985.

Sturm, Helmet et al, *Die Zeitschrift SPUR*, München: Gruppe Spur, 1962.

Trocchi, Alexander, *Cain's book*, New York: Grove Press, 1960.

Trocchi, Alexander, *Man at Leisure*, London: Calder and Boyars, 1972.

Trocchi, Alexander, *Invisible Insurrection of a Million Minds: A Trocchi Reader*, Edinburgh: Polygon, 1991.

Vaneigem, Raoul, *Traité de savoir-vivre à l'usage des jeunes générations*, Paris: Gallimard, 1967. Translated by Donald Nicholson-Smith as *The Revolution of Everyday Life*, Seattle, Washington: Left Bank Books and London: Rebel Press, 1983.

Vaneigem, Raoul (Ratgeb), *De la grève sauvage à l'autogestion généralisée*, Paris: Union générale d'editions, 1974. Translated by Paul Sharkey as *Contributions to the Revolutionary Struggle Intended to be Discussed, Corrected and Principally Put Into Practice Without Delay*, London: Bratach Dubh Editions, 1981.

Vaneigem, Raoul (Dupuis Jules-François), *Histoire désinvolte du surréalisme*, Nonville: Paul Vermont, 1977. Translated by Donald Nicholson-Smith as *A Cavalier History of Surrealism*, Edinburgh: AK Press, 1999.

Vaneigem, Raoul, *Le Livre des plaisirs*, Paris: Encre, 1979. Translated by John Fullerton as *The Book of Pleasures*, London: Pending Press, 1983.

Vaneigem, Raoul, *Le Mouvement du Libre-Esprit[sic]: généralitiés et témoignages sur les affleurements de la vie à la surface du Moyen Age, de la Renaissance et, incidemment, de notre époque*, Paris: Éditions Ramsay, 1986. Translated as *The Movement of the Free Spirit: General Considerations and Firsthand Testimony Concerning Some Brief Flowerings of Life in the Middle Ages, the Renaissance and, Incidentally, Our Own Time*, New York: Zone Books, 1994.

Viénet, René, *Enragés et situationnistes dans le mouvement des occupations*, Paris: Gallimard, 1968. Translated as *Enragés and Situationists in the Occupation Movement, France, May '68*, New York; London: Autonomedia; Rebel Press, 1992.

Wolman, Joseph, *L'Anticoncept*, Paris: Éditions Allia, 1994.

Andreotti, Libero and Xavier Costa eds., *Situationists: Art, Politics, Urbanism*, Barcelona: Museu d'Art Contemporani de Barcelona; ACTAR, 1996.

Andreotti, Libero and Xavier Costa eds., *Theory of the Dérive and Other Situationist Writings on the City*, Barcelona: Museu d'Art Contemporani de Barcelona; ACTAR, 1996.

Atkins, Guy (with the help of Troels Andersen), *Asger Jorn: The Crucial Years, 1954-1964*, London: Lund Humphries, 1977.

Atkins, Guy (with the help of Troels Andersen), *Asger Jorn: The Final Years, 1965-1973*, London: Lund Humphries, 1980.

Bandini, Mirella, *L'estetico il politico: da Cobra all'Internazionale Situazionista, 1948-57*, Roma: Officini edizioni, 1977.

Bataille, Georges, *Visions of Excess: Selected Writings 1927-1939*, Manchester: Manchester University Press, 1985.

Berréby, Gérard ed., *Documents relatifs à la fondation de l'Internationale situationniste: 1948-1957*, Paris: Éditions Allia, 1985.

Berréby, Gérard ed., *Textes et documents situationnistes, 1957-1960*, Paris: Éditions Allia, 2004.

Blazwick, Iwona ed., *An Endless Adventure... An Endless Passion... An Endless Banquet: A Situationist Scrapbook*, London: ICA and Verso, 1989.

Bourseiller, Christophe, *Vie et mort de Guy Debord*, Paris: Plon, 1999.

Bowd, Gavin and Andrew Hussey eds., *The Hacienda Must be Built: On the Legacy of Situationist Revolt*, Manchester: Manchester University Modern Literature Group/Aura, 1996.

Bracken, Len, *Guy Debord: Revolutionary*, Venice, CA: Feral House, 1997.

Brau, Éliane, *Le Situationnisme ou la nouvelle internationale*, Paris: Debresse, 1968.

Cravan, Arthur, *Oeuvres: Poems, Articles, Lettres*, Paris: Éditions Gérard Lebovici, 1987.

De Zegher, Catherine and Mark Wigley eds., *The Activist Drawing: Retracing Situationist Architectures from Constant's New Babylon to Beyond*, New York: The Drawing Center and MIT Press, 2001.

Donné, Boris, *(Pour Mémoires)*, Paris: Éditions Allia, 2004.

Dumontier, Pascal, *Les situationnistes et Mai 68: théorie et pratique de la révolution (1966-1972)*, Paris: Éditions Gérard Lebovici, 1990.

Elsken, Ed van der, *Love on the Left Bank*, London: André Deutsch, 1957.

Fjord, Ambrosius and Patric O'Brien, *Situationister 1957-70*, Vanlöse, Eksp: Concord, Jyllingevej 2, 1970.

Ford, Simon, *The Realization and Suppression of the Situationist International: An Annotated Bibliography, 1972-1992*, Edinburgh: AK Press, 1995.

Foster, Stephen C. ed., "Lettrisme: Into the Present", special issue of *Visible Language*, vol. 17, no. 3, Summer 1983.

Frith, Simon and Howard Horne, *Art into Pop*, London: Methuen, 1987.

Garlake, Margaret ed., *Artists and Patrons in Post-War Britain*, Aldershot: Ashgate, 2001.

Gombin, Richard, *Les Origines du gauchisme*, Paris: Seuil, 1971. Translated by Michael K Perl as: *The Origins of Modern Leftism*, Harmondsworth: Penguin, 1975.

Gonzalvez, Shigenobu, *Guy Debord, ou la beauté du negative*, Paris: Mille et une nuits, 1995.

Gray, Christopher ed., *Leaving the Twentieth Century: The Incomplete Work of the Situationist International*, London: Free Fall Publications, 1974.

Guilbert, Cécile, *Pour Guy Debord*, Paris: Gallimard, 1996.

Hahne, Ron and Ben Morea, *Black Mask and the Motherfuckers: The Incomplete Works of Ron Hahne, Ben Morea and the Black Mask Group*, London: Unpopular Books and Sabotage Editions, 1993.

Hansen, Per Hofmann, *A Bibliography of Asger Jorn's writings*, Silkeborg: Silkeborg Kunstmuseum and the Asger Jorn Foundation, 1988.

Harrison, Charles, and Paul Wood ed., *Art in Theory: 1900-2000: An Anthology of Changing Ideas*, Cambridge: Blackwell Publishing, 2003.

Home, Stewart, *The Assault on Culture: Utopian Currents from Lettrisme to Class War*, Stirling: AK Press, 1991.

Home, Stewart, *Cranked Up Really High*, Hove: Codex, 1995.

Home, Stewart ed., *What is Situationism? A Reader*, Edinburgh: AK Press, 1996.

Huizinga, Johan, *Homo Ludens: A Study of the Play Element in Culture*, New York: Harper and Row, 1970.

Hussey, Andrew, *The Game of War: The Life and Death of Guy Debord*, London: Jonathan Cape, 2001.

Jappe, Anselm, *Guy Debord*, Berkeley, CA: University of California Press, 1999.

Klein, Naomi, *No Logo*, London: Flamingo, 2001.

Lambert, Jean-Clarence ed., *New Babylon/Constant*, Paris: Cercle d'Art, 1997.

Lautréamont, *Maldoror and Poems*, Harmondsworth: Penguin Books, 1978. Translated by Paul Knight.

Lebovici, Gérard, *Correspondance*, vols 1 and 2, Paris: Éditions Ivrea, 1996.

Lefebvre, Henri, *Critique de la vie quotidienne*, vols. 1-2, Paris: L'Arche, 1958-1961. 3 vols. 1958-1981.

Loers, Veit ed., *Gruppe SPUR 1958-65: Lothar Fischer, Heimrad Prem, Helmut Sturm, H P Zimmer*, Regensberg: Städtische Galerie, 1986.

London Psychogeographical Association and the Archaeogeodetic Association, *The Great Conjunction: The Symbols of a College the Death of a King and the Maze on the Hill*, London: Unpopular Books, 1992.

Lydon, John, *Rotten: No Irish, No Blacks, No Dogs: The Authorised Autobiography*, London: Hodder & Stoughton, 1994.

McDonough, Tom ed., *Guy Debord and the Situationist International: Texts and Documents*, Cambridge, MA and London: MIT Press, 2002.

Mann, Paul, *The Theory-Death of the Avant-Garde*, Bloomington: Indiana University Press, 1991.

Marcus, Greil, *Lipstick Traces: A Secret History of the Twentieth Century*, London: Secker & Warburg, 1989.

Marwick, Arthur, *The Sixties: Cultural Revolution in Britain, France, Italy, and the United States, c.1958-c.1974*, Oxford: Oxford University Press, 1998.

Martos, Jean-François, *Histoire de l'Internationale situationniste*, Paris: Éditions Gérard Lebovici, 1989.

Martos, Jean-François, *Correspondance avec Guy Debord*, Paris: le fin mot de l'histoire, 1998.

Mauss, Marcel, *The Gift: Forms and Functions of Exchange in Archaic Societies*, London: Routledge & Kegan Paul, 1954.

Mercier, Luc, ed., *Archives situationnistes, volume 1*, Paris: Contre-Moule/ Parallèles, 1997.

Motherwell, Robert ed., *The Dada Painters and Poets: An Anthology*, Cambridge, MA: The Belknap Press of Harvard University Press, 1981.

Ohrt, Roberto, *Phantom avant-garde: Eine Geschichte der Situationistischen International und der modernen Kunst*, Hamburg: Edition Nautilus, Galerie van de Loo, 1990.

Obrist, Hans Ulrich, *Interviews: Volume 1*, Milan: Charta, 2003.

Pannekoek, Anton, *Workers' Councils*, San Francisco; Stirling: AK Press, 2003.

Plant, Sadie, *The Most Radical Gesture: The Situationist International in a Postmodern Age*, London: Routledge, 1992.

Raspaud, Jean-Jacques and Jean-Pierre Voyer, *L'Internationale situationniste: chronologie, bibliographie, protagonistes (avec un index des noms insultés)*, Paris: Éditions Champ Libre, 1972.

Reid, Jamie, and Jon Savage, *Up They Rise: The Incomplete Works of Jamie Reid*, London: Faber and Faber, 1987.

Reid, Jamie, *Celtic Surveyor: More Incomplete Works of Jamie Reid*, London: Assorted Images, 1989.

Sabin, Roger ed., *Punk Rock: So What? The Cultural Legacy of Punk*, London: Routledge, 1999.

Sadler, Simon, *The Situationist City*, Cambridge, MA and London: MIT Press, 1998.

Savage, Jon, *England's Dreaming: Sex Pistols and Punk Rock*, London: Faber & Faber, 1991.

Schrenk, Klaus ed., *Upheavals, Manifestos, Manifestations: Conceptions in the Arts at the Beginning of the Sixties: Berlin, Düsseldorf, Munich*, Köln: DuMont, 1984.

Scott, Andrew Murray, *Alexander Trocchi: The Making of the Monster*, Edinburgh: Polygon, 1991.

Sellem, Jean ed., 'Bauhaus Situationist', a special issue of *Lund Art Press*, vol. 2, no. 3, 1992.

Shield, Peter, *Comparative Vandalism: Asger Jorn and the Artistic Attitude to Life*, Aldershot: Borgen/Ashgate, 1998.

Starr, Peter, *Logics of Failed Revolt: French Theory After May '68*, Stanford: Stanford University Press, 1995.

Stokvis, Willemijn, *Cobra: The Last Avant-Garde Movement of the Twentieth Century*, Aldershot: Lund Humphries and V+K Publishing, 2004.

Sussman, Elisabeth ed., *On the Passage of a Few People Through a Rather Brief Moment in Time: The Situationist International 1957-1972*, Boston, MA.: M.I.T. Press and ICA, Boston, 1989.

Vermorel, Fred, *Fashion and Perversity: A Life of Vivienne Westwood and The Sixties Laid Bare*, London: Bloomsbury, 1997.

Wigley, Mark, *Constant's New Babylon: The Hyper-Architecture of Desire*. Rotterdam: 010 Publishers, 1998.

Wood, Alan, *The Map is not the Territory*, Manchester: Manchester University Press, 2001.

Picture Credits

Black Dog Publishing would like to thank Jakob Jakobsen, Liliana Dematteis at Archivio Gallizio, Maki Nanamori at Paula Cooper Gallery, Ron Warren at Mary Boone Gallery, Matthew Frost at Manchester University Press and Alan Ward at Axis Graphic Design.

# Index